RICHARD C. ELLIOTT PRIMAL OP

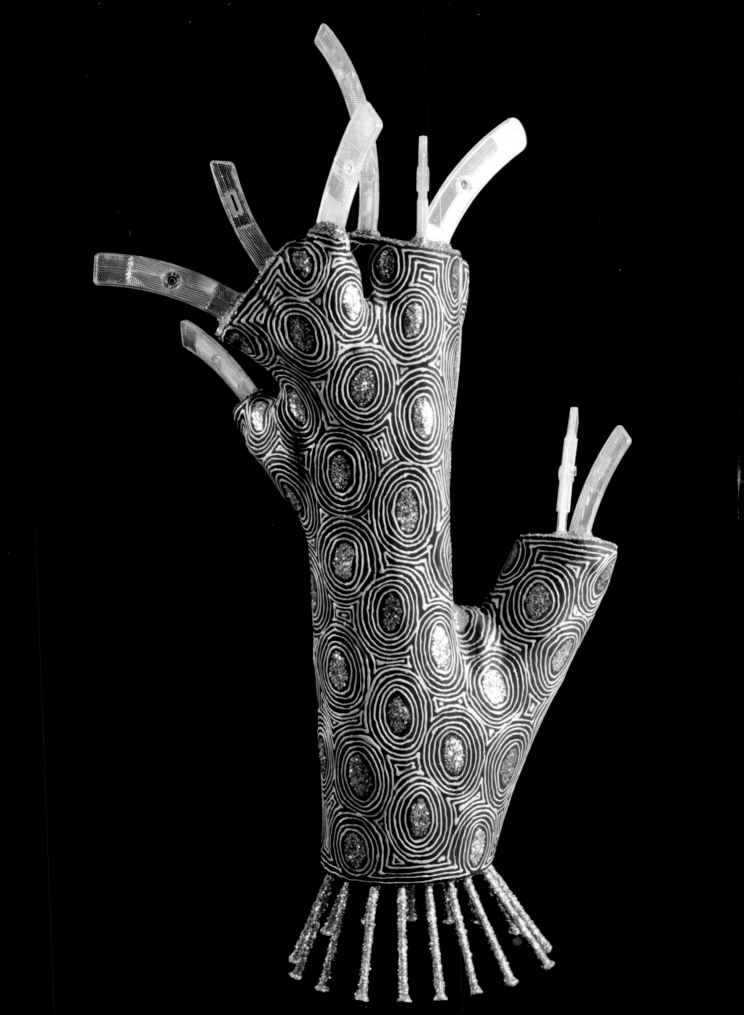

RICHARD C. ELLIOTT PRIMAL OP

SHEILA FARR

HALLIE FORD MUSEUM OF ART
WILLAMETTE UNIVERSITY
SALEM, OREGON

DISTRIBUTED BY
UNIVERSITY OF WASHINGTON PRESS
SEATTLE AND LONDON

This book was published in connection with an exhibition arranged by the Hallie Ford Museum of Art at Willamette University entitled *Richard C. Elliott: Primal Op*. The dates for the exhibition were May 31–August 24, 2014.

Financial support for the exhibition and book was provided by funds from Caroline Rubio, mother of Melvin Henderson-Rubio, WU '74. Additional support was provided by general operating support grants from the City of Salem's Transient Occupancy Tax funds and the Oregon Arts Commission.

Designed by Phil Kovacevich

Editorial review by Sigrid Asmus

Photography by Dale Peterson unless otherwise credited

Printed and bound in Canada by Friesen's Book Division

Front cover: *Four Color Variations* (detail), 2005, reflectors on panel, 4 panels: 45 x 45 in. each, collection of Jane Orleman, Ellensburg, Washington.

Back cover: *Marriage Wand*, early 1980s, wood, paint, reflectors, and ribbon, length: 50 in., collection of Jane Orleman, Ellensburg, Washington.

Frontispiece: *Firewood Piece 2*, mid-1980s, firewood, iridescent paint, glitter, nails, and reflectors, collection of Jane Orleman, Ellensburg, Washington.

Page 90: *Firewood Piece 1*, early 1980s, firewood, nails, and reflectors, 12 ¼ x 10 ½ x 10 ½ in., collection of Jane Orleman, Ellensburg, Washington.

Library of Congress Control Number 2014931947

ISBN 9781930957718

Distributed by
University of Washington Press
P.O. Box 50096
Seattle, WA 98145-5096

CONTENTS

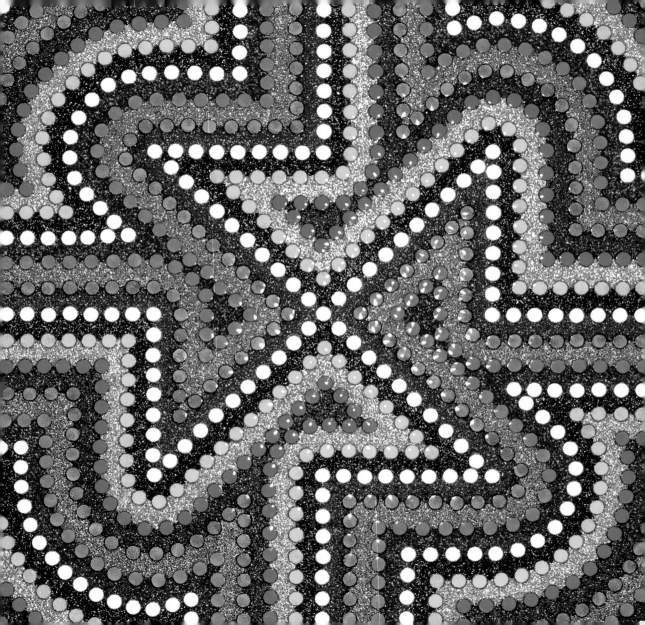

DICK ELLIOTT was an enormously talented mixed-media artist who lived and worked in Ellensburg, Washington. During a career that spanned forty years, he created a remarkable body of work— drawings, sculptures, an artist site (with his wife Jane Orleman), happenings, installations, paintings, neon sculptures, commissions, digital prints, and even ceramics—that attests to his energy, creativity, curiosity, restless spirit, and brilliant mind. He died from pancreatic cancer in 2008; one of the most innovative and original artists to emerge in the Pacific Northwest in recent memory and yet, sadly, one of the region's most under-recognized artists as well.

Born in Portland, Oregon, in 1945, Dick was educated at public schools in Portland and received his BA degree from Central Washington University in Ellensburg in art and economics. During the 1970s he made highly realistic drawings of the people and places he loved, weaving light and form together to capture a particular moment in time. By the early 1980s, however, he no longer felt that he could express what he had in mind about light and natural structure with graphite and paper. He began to explore primary colors and light-active materials and, by 1987, decided to focus on the Sate-Lite reflector as his medium of choice.

During the late 1980s and early 1990s, Dick's exploration of light, reflectivity, color, and natural structure manifested itself in a number of site-specific works, including major installations at Central Washington University in Ellensburg and the University of Idaho in Moscow, among others. Dick would take over a gallery space, cover the walls with thousands of reflectors in amber, clear, blue, green and red, eliminate gallery lighting, equip visitors with flashlights, and thus create a wonderful "reflective light" experience for the viewer.

By the mid-1990s, Dick's installations had given way to reflectors mounted onto canvas and wood. Combining Sate-Lite reflectors with two-dimensional geometric designs, he set about to create a body of work that would have the glitz and glitter of our high-tech

Pathfinder, 1987, glitter and reflectors on canvas, 55 x 55 in., collection of Jane Orleman, Ellensburg, Washington.

culture, but that at the same time would serve as a magical bridge to other cultures and other times. During the last year of his life, Dick turned his attention to a series of computer-generated prints utilizing thousands of different colors and geometric designs.

In addition to his site-specific installations and studio work, Dick was engaged in a number of major art commissions throughout his career. His commissions have graced the Henry Art Gallery at the University of Washington; the Sun Dome in Yakima, Washington; and numerous schools, transit centers, colleges, and airports throughout the United States. In 2008, he was commissioned to create *Portals Through Time*, a series of forty-five reflector panels for the second-floor windows of the Hallie Ford Museum of Art.

When Dick passed away in 2008, I told his wife Jane Orleman that I wanted to organize a major retrospective exhibition and book that would document his life and art and would call attention to the important contributions he made to contemporary regional art, and I am thrilled that the project has finally come to fruition, even though it has taken a number of years to complete. Indeed, a project of this magnitude and scope would not have been possible without the help and support of a number of creative and talented individuals, and I would like to take this opportunity to acknowledge and thank them for their commitment and support.

I would like to express my thanks and appreciation to art writer Sheila Farr for agreeing to write the essays in the book. I first met Sheila when she was an art writer for the *Bellingham Herald* in the early 1990s and I was deputy director of the Whatcom Museum of History and Art, and we have remained friends and colleagues over the miles and years. Sheila is a warm and vivacious woman and a superb writer who jumped at the opportunity to write about Dick when I asked her if she would be interested in 2010, and who has written a lively and entertaining account of his life and art.

I am further indebted to Dick's wife, partner, and soul mate Jane Orleman, who catalogued, stored, and documented Dick's work, and who made my curatorial selection of objects in the exhibition easy because of her remarkable organizational skills and records. Jane was extremely helpful to Sheila during the research phase of the project, sorting through files, newspaper articles, and old photographs to help her with research. In addition, she arranged for Sheila to meet with many of Dick's old friends and colleagues who in turn provided further memories of Dick as a brother, roommate, colleague, collaborator, and friend.

I would like to thank graphic designer Phil Kovacevich for another beautifully designed book (our sixteenth book with Phil in thirteen years), and Sigrid Asmus for her careful editing of Sheila's essay. In addition, I would like to express my thanks and appreciation to the University of Washington Press for their ongoing support of our publications, and to photographer Dale Peterson, whose stunningly beautiful photographs of Dick's work grace the pages of this book. Dale spent six days in Salem, Ellensburg, and Seattle last winter shooting Dick's work and countless hours back in Portland getting the photographs ready for publication.

Financial support for the exhibition and book was provided by funds from Caroline Rubio, mother of Melvin Henderson-Rubio, WU '74. Melvin saw Dick's work for the first time when we presented *Dick Elliott: Wall of Light* in the Mary Stuart Rogers Performing Arts Center in 2000, and became an immediate supporter and fan. He eventually purchased several works by Dick for his personal art collection, and when I told him that I wanted to honor Dick with a major exhibition and book after Dick passed away in 2008, he told me he wanted to help. Additional financial support for the exhibition and book was provided by general operating support grants from the City of Salem's Transient Occupancy Tax funds and the Oregon Arts Commission.

Finally, and by no means least, I would like to thank my talented and dedicated staff for their help with various aspects of the project, from preparing checklists and loan contracts to installing, promoting, and marketing the exhibition: collection curator Jonathan Bucci; education curator Elizabeth Garrison; exhibition designer/chief preparator David Andersen; collections assistant Melanie Weston; membership/public relations manager Andrea Foust; administrative assistant Carolyn Harcourt; front desk receptionists Elizabeth Ebeling, Bonnie Schulte, and Emily Simons; safety officer Frank Simons; and custodian Cruz Diaz de Estrada.

9

JOHN OLBRANTZ

The Maribeth Collins Director

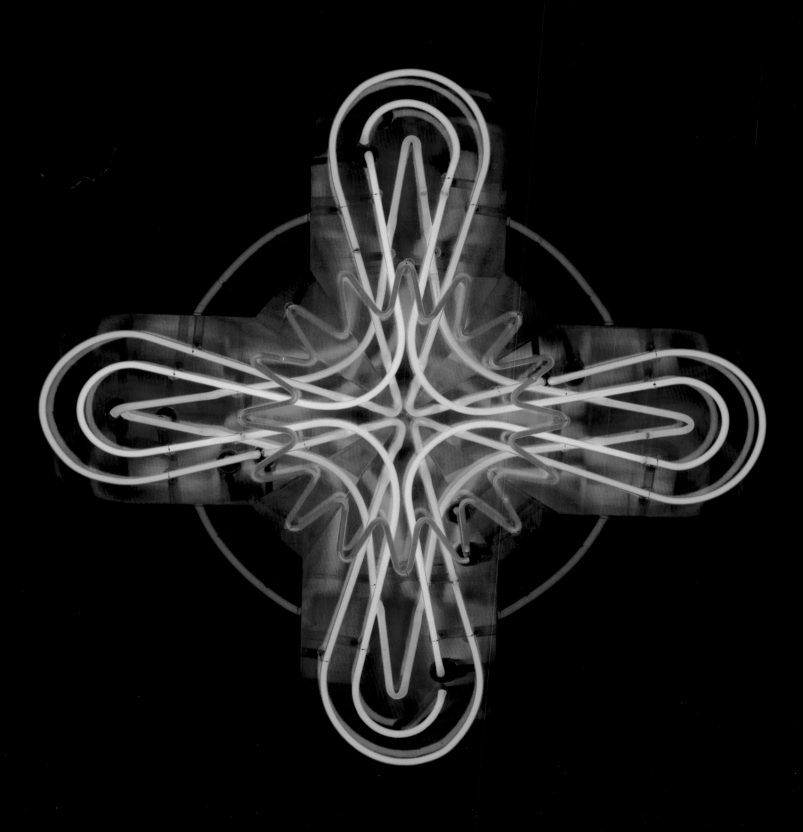

THIS BOOK AND RETROSPECTIVE owe their existence to John Olbrantz, a supporter of Dick Elliott's work long before it was popular or fashionable. Olbrantz—now The Maribeth Collins Director of the Hallie Ford Museum of Art at Willamette University in Salem, Oregon—has a deep commitment to exhibiting and documenting significant contemporary artists of the Northwest. It was an honor and a pleasure to work with him on this project.

Many people contributed their time and memories of Dick Elliott for this book. My thanks go first and foremost to Jane Orleman, who tracked down information, sorted through news clippings, e-mail files, and old photographs, and spent many hours in conversation to create this profile of her late husband and his career. Jane's patience and hospitality were exemplary throughout. On behalf of the Elliott family, Dick's brother Jim Elliott stood in as a representative and offered his efficient, well-documented recollections and personal insights.

Dick left vivid impressions on all who knew him and many friends and colleagues shared their stories and remembrances. I am grateful to his longtime assistant and fabricator, Dick Johnson, and close friends John Bennett, Boyd Ditter, John Hofer, Doug Martensen, and Nancy Worden for taking time to talk about Dick's character and accomplishments. Jim Brand, Burr and Eileen Beckwith, Dorrance Denner, Cathy Schoenburg, Wally Warren, and Andy Willis also contributed their recollections; Ken Slusher kindly shared his photographs and documentation of the Rock Festival.

Finally, at the Seattle Art Museum, curators Pam McClusky and Barbara Brotherton offered information and assistance. For insights into Dick's work, my appreciation goes to Chris Bruce, Director of the Museum of Art at Washington State University in Pullman, whose early recognition of Elliott's talent was instrumental in launching his career.

SHEILA FARR

11

Kittitas Valley Hex, 1994–96, neon, 48 x 48 in., collection of Jane Orleman, Ellensburg, Washington. Photo: Harry Thompson.

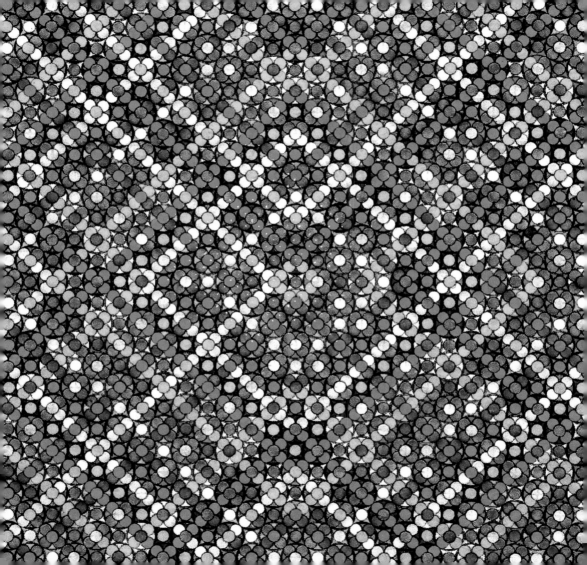

IN A SIMPLE UTILITARIAN OBJECT, the plastic reflector, central Washington artist Richard C. Elliott found a way to make magic.

He combined hundreds of thousands of them over the years to develop his unique, gemlike art medium of radiant color and design (figs. 1–5). Other media appealed to Elliott in the course of his career, from graphite and paint to mixed-media assemblages, neon, and high-resolution digital prints. But the mass-produced orbs of Sate-Lite reflectors were his signature material; their five basic colors—red, amber, green, blue, and white—his palette. Using a process he patented in 1992, Elliott composed them, layer upon layer, into intricate variations of archetypal patterns.

Pattern is the heart of Elliott's work and light is its spirit. The beam of a flashlight or a ray of sunlight jolts the imagery into life, turning an installation of multicolored reflectors into a walk-in kaleidoscope. Silvery as moonlight on water or explosive as fireworks: the possibilities of the medium seemed limitless to Elliott and kept him spellbound for the last three decades of his life (fig. 6). "The quest for the radiant is the driving force behind my art," he said.[1]

To Elliott the dance of reflected light was a living thing, something viewers respond to instinctively. He worked in a visual language common across cultures: American Indian or African, Australian Aboriginal or ancient Chinese, Islamic, or Christian. Throughout art history Elliott found the same geometric and organic shapes, the same expanding spirals and circles, in various permutations, over and over. "Often what these patterns speak about is a mystical or spiritual unity with the living fabric. They act as doors, windows and bridges connecting the individual or group to the unseen world," Elliott wrote. "Our spirit instinctually ascends when we encounter them."[2]

With his reflector pieces—whether freestanding assemblages on canvas, elaborate museum installations, or grand-scale public art

13

Figure 1
Unity Weave #2, 1989, reflectors on canvas, 60 x 60 in., collection of Kevin Gallagher, Lake Forest Park, Washington.

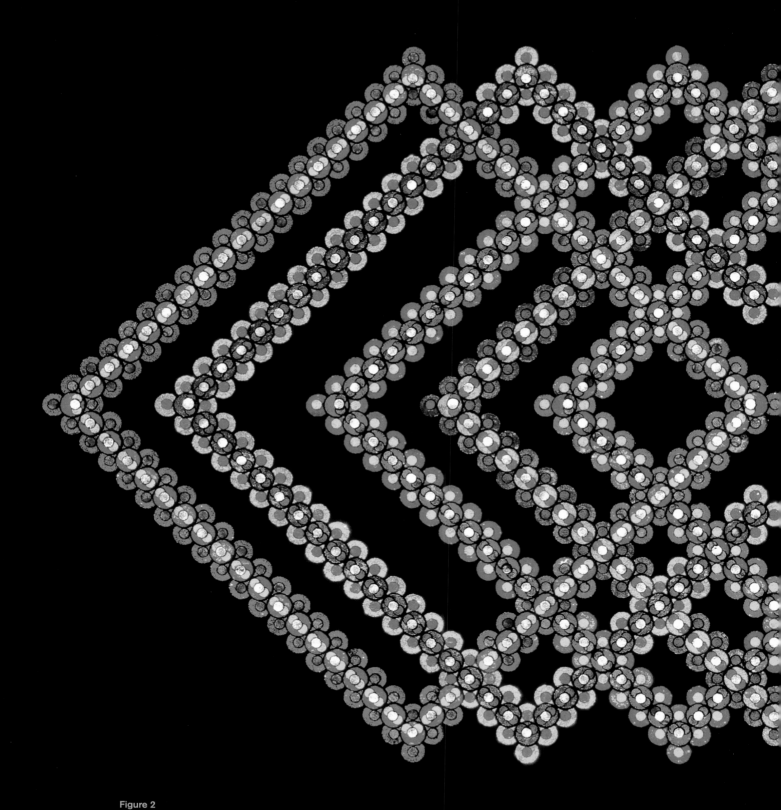

Figure 2
Seven Diamonds,
ca. 1992, reflectors on
shaped support,
88 x 178 in., collection of
Jane Orleman, Ellensburg,
Washington.

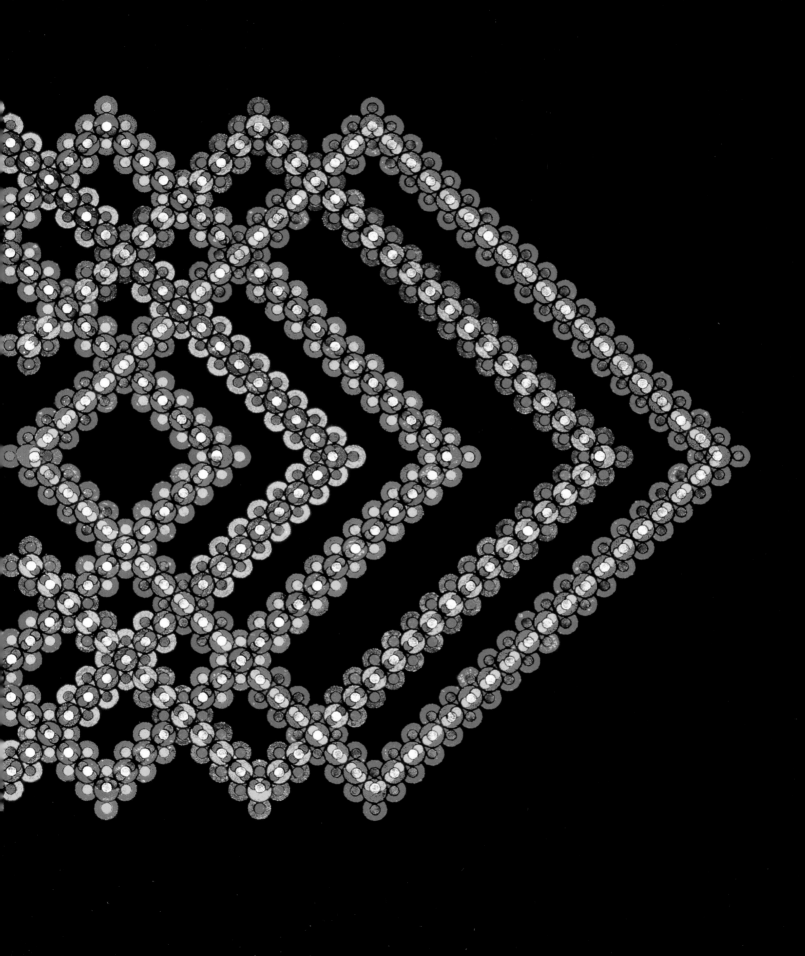

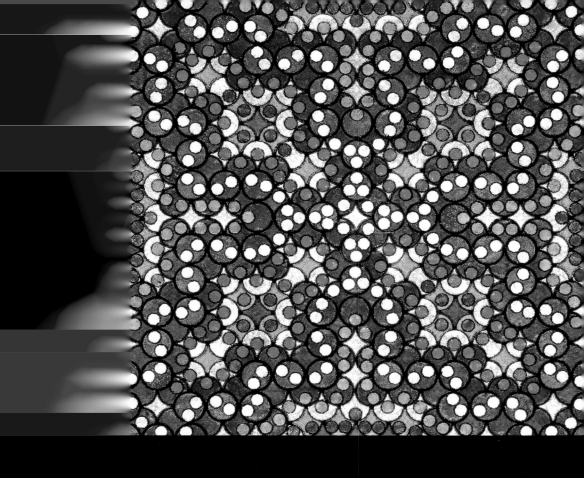

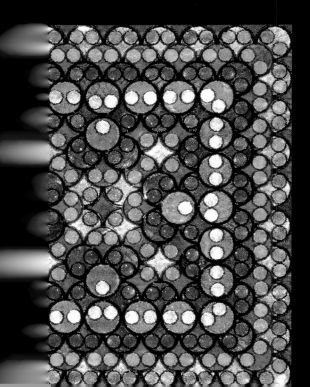

Figure 3
Primal Fires: 14-2-45,
2003, reflectors on panel,
45 x 45 in., collection of
Jane Orleman, Ellensburg,
Washington.

Figure 4
Central Core #2, 2005,
reflectors on panel,
32 x 32 in., collection of
Jane Orleman, Ellensburg,

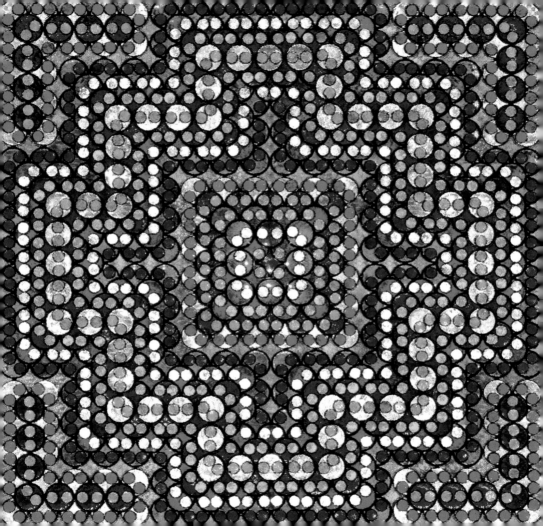

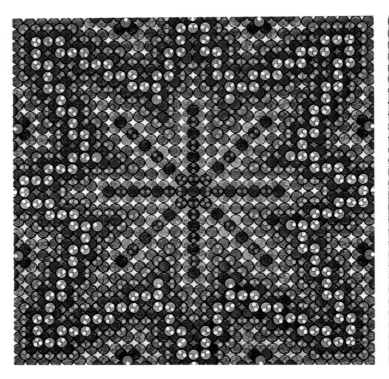

installations—Elliott joined the polish of his academic art training
and the sparkle of reflectors with the brainstem appeal of radiant
designs. Rooted in the psychedelic palette and the throbbing, rock
and roll, lightshow aesthetic of the 1960s, his images bear striking
similarities to the work of more famous contemporaries, including
Chuck Close (figs. 7–8).

Elliott's breakthrough came after years of stylistic experimenta-
tion. After earning a college art degree, he began his career in a
traditional way, faithfully reproducing landscapes and portraits in
large-scale graphite drawings that took months of labor to com-
plete. Later, an epiphany led him to abruptly change course. His
first Seattle gallery exhibitions in the 1980s were installations of
totems, fetishes, and canvases that borrowed heavily from Native
American imagery and Australian Aboriginal paintings. Adopting
the persona of a witch doctor or magician, Elliott enacted self-
styled rituals in costumes he created. During that same period,
Elliott and his wife, the artist Jane Orleman, created a fanciful, folk-
art inspired garden at their Ellensburg home that quickly became a
magnet for feature writers, television news reporters, filmmakers,
and guidebook authors (fig. 9).

The garden gave Elliott a place to try out the kinds of found materi-
als he was attracted to and formulate his ideas about art-making
into a guiding philosophy. A translucent fence he assembled from
discarded glass electrical insulators (fig. 10) and a garage-wall

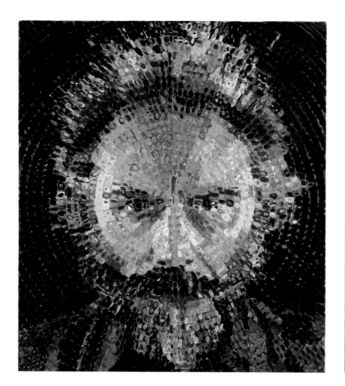

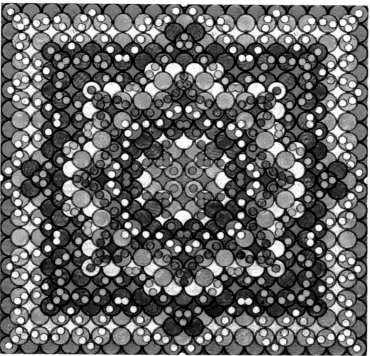

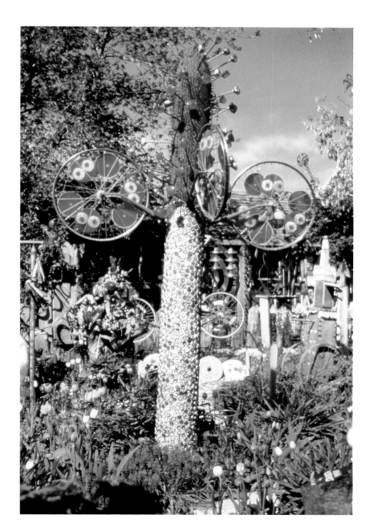

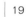 19

Figure 7 (top left)
CHUCK CLOSE
(American, born 1940),
Lucas II, 1987, oil on
canvas, 36 x 30 in.,
private collection. Photo:
© Chuck Close,
courtesy Pace Gallery.

Figure 8 (above)
Meditation Series—
Symbols of Radiance:
18-2-58, 1998, reflectors
on panel, 58 x 58 in.,
collection of the Yakima
Valley Museum, Yakima,
Washington.

Figure 9 (left)
Moon Tree, 1988,
Dick and Jane's Spot,
Ellensburg, Washington.
Photo: Richard C. Elliott
Estate.

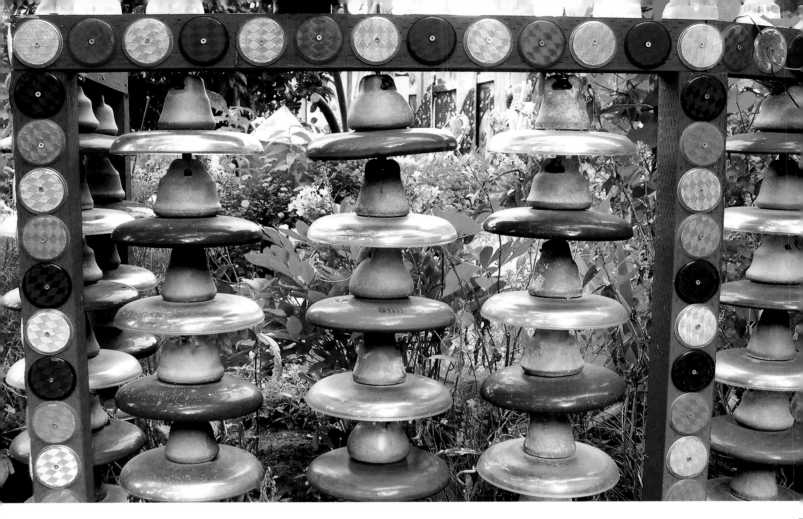

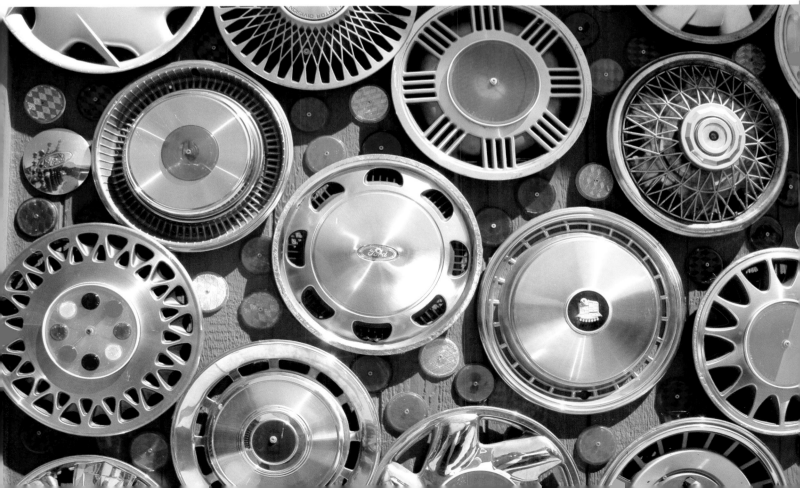

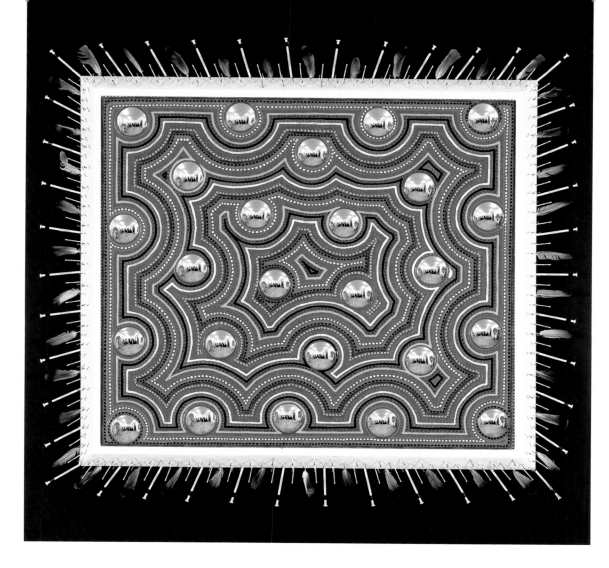

mosaic of orphaned hubcaps (fig. 11) spring from the same principles of light and pattern that informed Elliott's reflector pieces. Dick's collaborations with Jane in the yard spurred both of them to grow independently in their studio work. As he later wrote, "Our like minded attitude and mutual support has played a major role in allowing my art to develop into a distinct independent vision, not tied to academic or art world stylistic trends."

The early periods of Elliott's work—and the extraordinary series of paintings and prints he realized during the final years of his life—will be explored in later sections of this book.

By the 1980s, Elliott had homed in on light-reflective materials in a striking group of mixed-media paintings that incorporated glitter, mirrors, reflectors, and iridescent paint (fig. 12). In 1988 he showed them, along with his fetish-style constructions, at Seattle's Mia Gallery, part of the burgeoning gallery scene in Pioneer Square. Gallery owner Mia McEldowney was collecting and marketing the work of self-taught Southern artists as well as Northwest artists whose imagery fit that "outsider" aesthetic, riding the crest of a big wave

Figure 10
(opposite, top)
Insulator fence, Dick and Jane's Spot. Photo: Jane Orleman.

Figure 11
(opposite, bottom)
Hubcap wall, Dick and Jane's Spot. Photo: Jane Orleman.

Figure 12 (above)
Winter Moon, 1984, paint, nails, feathers, and convex mirrors on canvas, 59 x 65 in., collection of Jane Orleman, Ellensburg, Washington.

Figure 13
Northern Lights, 1987,
glitter and reflectors
on canvas, 55 x 55
in., collection of Jane
Orleman, Ellensburg,
Washington.

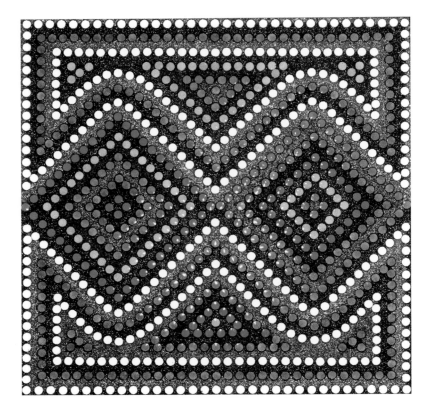

22

of interest in folk art. Her gallery was a happening place and Elliott's dynamic *Light in Spirit* exhibition drew attention.

This was a transitional moment for Elliott and his first major one-person show in Seattle. He threw everything he had into it, squeezing some one hundred twenty-five pieces into the gallery, including seven large canvases. The big, bold central patterns of these works expand the snail-shell design of ancient rock paintings and stratified diamonds of Native basketry to a grand scale, as we can see in *Northern Lights* (fig. 13). These basic symbols are the elementary structures of the cosmos, Elliott believed, and therefore the most authentic forms for art making as well. But he was also intrigued with the way certain combinations of pattern and color can trick our eyes into illusions—the science of optics. In *Northern Lights* he plays opposite colors against each other in the twin diamond shapes of his composition—red on one side, green on the other—which, as you look, begin to oscillate and veer into psychedelic distortions.

An untitled canvas from that show stands out, a one-off experiment with iridescent resist paint that points to a broad facet of Elliott's later work (fig. 14). This nine-part grid, with each section an amazingly elaborate radiating design, demonstrates Elliott's obsessive need to work through all the possible variations on a theme, as well as his ability to focus almost limitless attention on minute

detail. From a central point on each part of the grid, hundreds of lines and dashes comprise a different spiral, wave, or starburst form. When you stare into these force-fields, they seethe. The work is strikingly akin to the instinctive patterning of Aboriginal artists, such as Kathleen Petyarre (fig. 15).

Reviewing the Mia show, critic Matthew Kangas focused on the bold-patterned mixed-media canvases, comparing them to the hard-edged graphics of Kenneth Noland, Jasper Johns, and Francis Celentano. But he noted a rift between Elliott's paintings and the more primitive sculptures. "[Elliott] seems torn between the primitivism of the totems and the sleek assertiveness of the reflectors. For me, the only way to go is toward the future, leaving behind the atavistic and totemic."[3]

That, in fact, was the direction Elliott's work was headed. Unfortunately, Elliott had already been typecast in some circles. When the Mia Gallery closed in 1997, *Seattle Times* art critic Robin Updike noted: "Because their work is so different from what is shown in most Seattle galleries, it's likely that many of Mia's artists will not find representation elsewhere in Seattle."[4]

That statement turned out to be prophetic for Elliott. His affiliation with Mia, along with the funky aesthetic of Dick and Jane's

Figure 14
Meditations, 1987, iridescent resist paint on canvas, 61 x 61 in., collection of Jane Orleman, Ellensburg, Washington.

Figure 15
KATHLEEN PETYARRE (Alyawarra, from Utopia, Northern Territory, born 1940), *Mountain Devil Lizard Dreaming*, 1996, synthetic polymer paint on canvas, 48 1/16 x 48 1/16 in., Seattle Art Museum, promised gift of Margaret Levi and Robert Kaplan, T97.37. Photo: Seattle Art Museum.

Ellensburg house, led many people to categorize the couple as outsider artists—a term that refers to self-taught artists working with makeshift materials—even though they both held college art degrees. Having their house featured in books such as *Strange Sites* and *Weird Washington*,[5] and being a destination for outsider-art aficionados around the country, was great fun; but that kind of celebrity came with a price. When Elliott went looking for gallery representation in Seattle and Portland, he sometimes found himself pigeonholed as that folk art guy who did stuff with reflectors.

Occasionally Dick would protest on his and Jane's behalf: "That's not true. Even though we didn't pay attention in class, we aren't totally untrained."[6]

Fortunately Elliott found an influential champion in Seattle. Chris Bruce, then curator at University of Washington's Henry Art Gallery, had a great eye for outside-the-box talent and the courage of his convictions. He'd seen some of Elliott's reflector pieces and was wowed by their gut-level impact and the sophisticated rationale and technique behind them. The Henry had opened in 1927 as Washington state's first public art museum, housed in a Gothic-revival brick building at the edge of the University of Washington campus.[7] Bruce invited Elliott to create a temporary installation for the space. They settled on a series of reflector assemblages that would fit into nine arched alcoves around the building's exterior.

Elliott's installation *Cycle of the Sun* was an audacious postmodern treatment of a campus landmark (fig. 16). While referencing the stained glass of Gothic cathedrals, the prefab plastic material of Elliott's piece is distinctly Pop art in temperament. From a purely aesthetic standpoint, the reflector panels captivate. Catching the sunlight as it arcs throughout the day and deflects from other sources, the designs ignite from place to place on the museum's facade in spectacular blazes of color. Conceptually, they form a lighthearted trompe l'oeil illusion, a blend of "high" and "low" art that brings the period architecture into sync with the contemporary exhibitions inside.

Bruce has described Elliott as "one of the great innovators in the history of Northwest art and one of the most accomplished yet under-recognized artists in America."[8] He still laughs remembering how many people came up to him and said: "I didn't know the Henry had stained glass windows."[9]

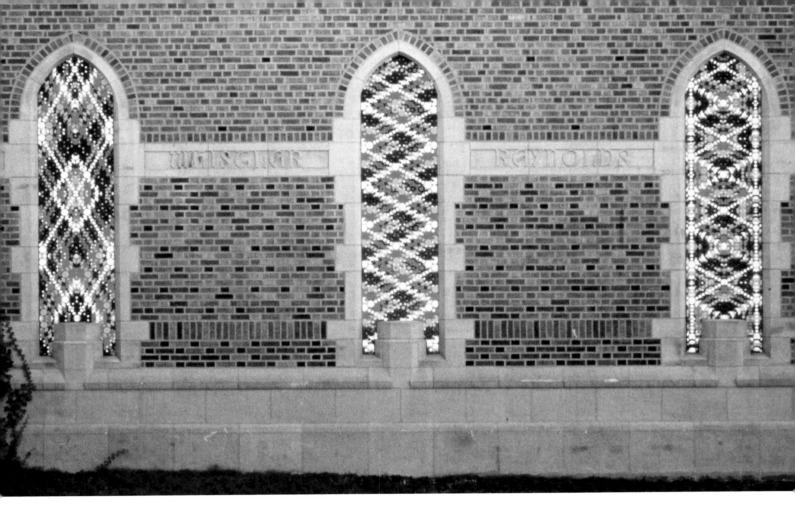

Originally slated to remain in place for one year, *Cycle of the Sun* was purchased for the Henry Art Gallery's permanent collection and now is reinstalled periodically. When in place, Elliott's piece shares the Henry exterior with the ovoid satellite of James Turrell's Sky Space, *Light Reign*, installed in 2003 at the old front entrance of the museum. Elliott's work holds its own in such heady company. Both artists designed their artworks to reveal the dynamics of natural light and evoke the sensation of religious spaces.

The Henry installation was a breakthrough for Elliott, the kind of curatorial affirmation that brought him a rush of offers from local college galleries—in Moscow, Idaho, and Yakima, Ellensburg, Skagit Valley, and Cheney in Washington—in addition to small museums around the Northwest—in Boise, Spokane, Bellingham—to create major interior installations of his reflector pieces. Surefire crowd-pleasers, Elliott's laboriously constructed light-shows took experiential art to new extremes. In enclosed darkened galleries, viewers donned headlamps so they could individually activate the reflectors—each audience member controlling his or her own experience of the work. Even in a typical gallery environment, audiences were transported. As reviewer Lillian Stillman noted: "Through an intuitive alternation of light-absorbing

Figure 16 *Cycle of the Sun*, 1989–90, Henry Art Gallery, University of Washington, Seattle. Photo: Richard C. Elliott Estate.

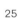 25

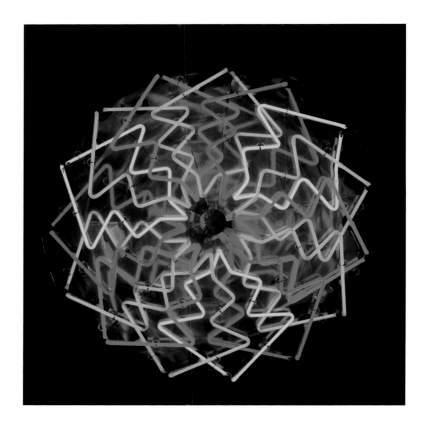

26

and light-reflecting colors, Elliott propels the viewer into the very matrix of vibrating energy that pervades, surrounds and interlocks all matter." [10]

Elliott told an interviewer: "I had found the means to overcome the artist-viewer barrier." [11]

In 1993, Elliott took his fascination with light one step further by using a $5,000 Western States Art Federation grant to enroll in the Neon Art and Tube Bending School in Portland, Oregon. With that difficult technique as part of his repertoire, Elliott began making artworks that could produce light rather than simply reflect it from other sources. Ever eager to explore new territory, Elliott soon began integrating neon into his reflector installations, ramping up the wow factor.

One of those installations, at Bellingham's Whatcom Museum of History and Art in 1996, brought Elliott into his first collaboration with that museum's deputy director John Olbrantz, now director of the Hallie Ford Museum of Art, who became one of his most important allies. Installing *Explorations in Light* (fig. 18) turned into a harrowing experience as Elliott and Olbrantz, along with the museum's work-study students, interns, and staff, spent long days following Elliott's layered design drawings as they nailed some 10,000 colored

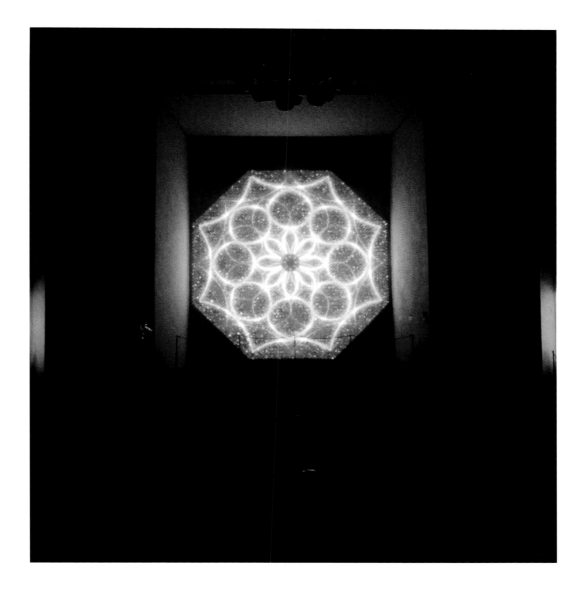

reflectors on the walls in two large-scale pieces: *Seeing the Light*, a 6 ½ by 17 foot design installed on two walls, and the 16 by 16 foot *Body and Soul*. A week later, the multifaceted exhibition still incomplete, Olbrantz realized there was no way it would be ready by the opening date. He took a deep breath, postponed the reception, sent out a press release, and kept on working.

Any installation exhibit comes with challenges. This one—as always with Elliott's work—was outrageously complex and time-consuming, and at the Whatcom Museum, Elliott and Olbrantz pulled out all the stops.[12] They added two large-scale individual reflector assemblages on canvas, nine neon pieces, plus a display of Elliott's masks, rocks, medicine sticks, and other related objects from early performances. The darkened rooms, aglow with neon and patterned reflectors that fluctuated with a viewer's every movement, felt like a cross between a cathedral and a psychedelic lightshow. When the exhibition finally

Figure 18
Installation view of the exhibition, *Explorations in Light*, 1996, Whatcom Museum of History and Art, Bellingham, Washington. Photo: Richard C. Elliott Estate.

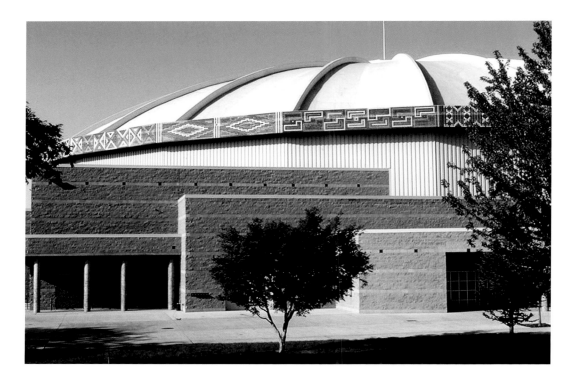

Figure 19
Circle of Light, 1992,
Sun Dome, Yakima,
Washington. Photo: John
Marshall.

opened, everyone was exhausted. But the extraordinary effort and stress were worth it. "People just really loved it," Olbrantz recalled. "They were blown away."[13]

It didn't matter that the transformers for the neon kept making crackling sounds and an occasional whiff of burning wires hovered in the galleries. Everything held up. And as word of mouth spread, the crowds grew.

This was the heyday of installation art, which included light and space works by Turrell; ritualistic performances by Marina Abramović; and the unclassifiable building-wrapping and landscape-embellishing by celebrity artist Christo, all of whom aimed to generate a state of awe or heightened consciousness in their viewers. Elliott was well aware of these trends, which suited his own proclivities. One thing he especially enjoyed about the installation work was its temporality. When the show is over, the work no longer exists: it just returns to the original components. Kind of like life.

Elliott lived for the installation work. It thrilled him to puzzle out the intricacies of a particular space and find a way to inhabit it with some unique concatenation of imagery and luminescence. Yet at the same time he was also gaining a reputation for another aspect of his work, one that, for a change, came with a paycheck. In 1992 Elliott—with a portfolio of large-scale museum installations to back him up—won his first high-profile public art commission: to create

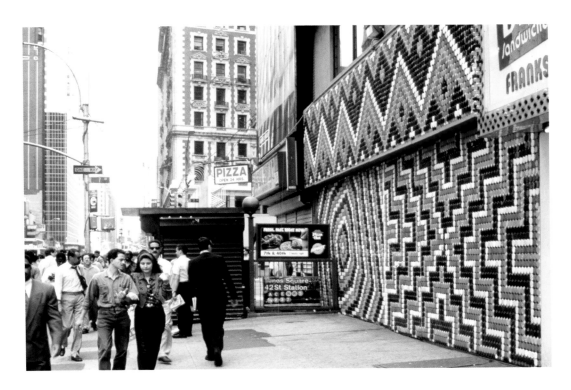

a sparkling hatband of reflector patterns for Yakima's new sports arena, the Sun Dome (fig. 19).

Basking in a near-constant wash of high desert sunshine, the venue seemed custom-tailored to Elliott's medium and his imagery. He called his 1992 artwork *Circle of Light*, and gave it a regional hook by choosing six patterns from the traditional cornhusk basketry and beadwork of the Yakama Nation. As Jane recalls, Dick was invited by members of the tribe to view works in the Yakama Nation Cultural Heritage Center. He added designs from other world cultures as well and defined the imagery as "primal cosmic symbolism."[14]

The logistics of the project were daunting. After three months of design and planning, Elliott and an assistant spent six long weeks strapped to a safety rope on a network of scaffolding, reading off combinations of colors from a design plan. Glue-gun in hand, in the heat and glare of August, Elliott affixed, one by one, nearly 50,000 reflectors (48,480 to be exact) in precise combinations around the full circumference of the stadium's concrete rim: a circle 5 ½ feet high and 880 feet around. It was mind-numbing, sweat-drenching, vertiginous work. Still, for the artist, this was a dream job.

Immediately popular, *Circle of Light* brought him a wash of new public art opportunities. The most exciting was in Times Square, at the gritty core of Manhattan, in 1993 (fig. 20). Elliott's 17 by 40 foot mural, installed on the wall of a building slated for demolition,

Figure 20
Noise Reduction Apparatus #1, 1993–94, Times Square, New York, New York. Photo: Richard C. Elliott Estate.

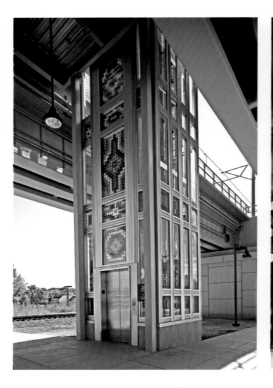

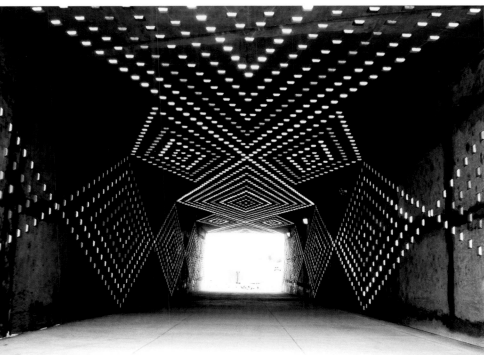

Figure 21
Tower of Light, 2007, CATS Archdale Station, Charlotte, North Carolina. Photo: JoAnn Sieburg-Baker.

Figure 22
Thunder Over the Rockies, 2007, Regional Transportation District, Belleview Light Rail Station, Pedestrian Tunnel, Denver, Colorado. Photo: Richard C. Elliott Estate.

landed a photograph of the jazzy, light-amplified reflector mosaic on the cover of the art section of the *New York Times*. The zigzag patterns of Elliott's piece took center stage, right at home in the aggressive buzz of 42nd Street. Part of an outdoor exhibition organized by the nonprofit arts organization Creative Time, the installation put Elliott in company with such art-world celebrities as Jenny Holzer, Vito Acconci, James Luna, Nam June Paik, Karen Finley, Liz Diller, and Ric Scofidio. The critics gravitated to the big names, but the photographers often focused on Elliott.

That commission and those that followed established Elliott as a public art administrator's dream—first and foremost because his artwork is easy to love. Elliott's patterned lightscapes didn't stir the controversies that frequently crop up around more esoteric contemporary artworks.

In addition, from a practical standpoint, the reflectors are a nearly indestructible medium and Elliott was a perfectionist. He engineered and constructed his assemblages to last—avoiding the costs and headaches of maintaining and repairing more fragile artworks.

And finally, Elliott—unlike many visual artists—was a trained and gifted salesperson, who took a degree of pleasure in the at-times-maddening bureaucratic process that has grown up around public art programs. He approached the hurdles of applications and proposals the same way he did most difficulties: he just kept at it. (He

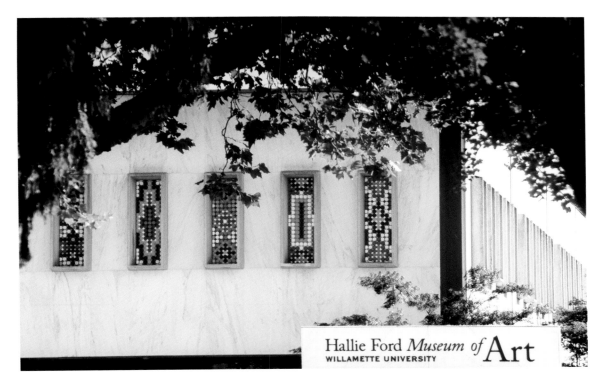

and Jane liked to joke that if you weren't getting three rejections a month, you weren't working hard enough.) The showmanship and competiveness of the interviews suited him just fine. Elliott was an avid talker, intense and forceful, yet in the end he knew it all came down to visuals. Toting elaborate folding scale models of his proposals in suitcases across the country, he'd unveil them like a magician to dazzle the selection committees. It worked. And once he got the contract, Elliott delivered.

But just when Elliott's optimism and popularity were flying high, he suffered a dangerous setback. On March 3, 1995, an accident in his neon shop exposed Elliott to toxic mercury vapors. Hospitalized in critical care for a week, he sustained damage to his heart and a string of other ailments that left him incapacitated for several years, in and out of the emergency room, dependent on Jane and his assistants. His seemingly endless capacity for hard physical work vanished in a flash. "A life threatening and life altering experience shakes one to the core," he later wrote. "It is often years before one understands its full impact; however, it has reaffirmed my quest to perceive the radiance of life and to express that shimmering brightness using a language understandable by all."

Elliott carried on, bolstered in 1998 by the insertion of a pacemaker to prod his heart along. Between *Circle of the Sun* in 1992 and his death from pancreatic cancer in 2008, Elliott was able to complete some twenty public art installations. Working frenetically

Figure 23
Portals Through Time, 2008, Hallie Ford Museum of Art, Willamette University, Salem, Oregon.

31

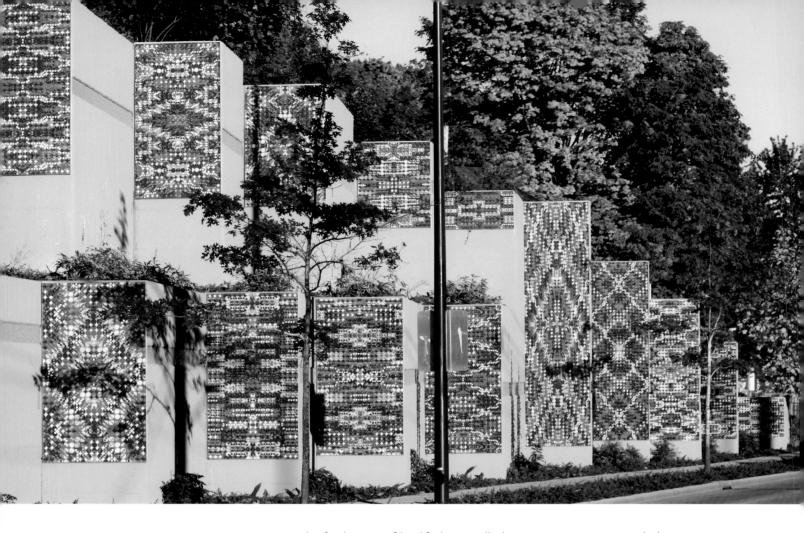

Figure 24
Sound of Light, 2008,
Seattle Sound Transit,
Light Rail Corridor,
Seattle, Washington.
Photo: M R McDonald.

in the final years of his life he installed seven major pieces, including, in 2007, *Tower of Light* (fig. 21), a striking vertical composition for a freestanding elevator at the Archdale Station at Charlotte, North Carolina, and *Thunder Over the Rockies* (fig. 22), a light-inflected contemporary cave painting at the Belleview Light Rail Station in Denver, Colorado. In 2008 Elliott completed *Portals Through Time* (fig. 23), a series of window panels that sparkle like jewelry around the beige neckline of the Hallie Ford Museum of Art.

He also completed the landmark *Sound of Light* in Seattle, a thirty-seven-panel, two-block-long drive-by experience that stretches along Sound Transit's Light Rail Corridor on Martin Luther King, Jr. Way (fig. 24). For that commission, Elliott received the Americans for the Arts award in Recognition for Innovation in Public Art. He was bedridden and could not attend the award ceremony in Philadelphia. In January 2008, he also received Washington State's highest honor in the arts, the Governor's Award.

Elliott had a number of helpers, many of them art students, who labored with him over the years, cutting and drilling, gluing and nailing the thousands upon thousands of reflectors that comprise these enormous artworks. But from the late 1990s on, his primary

fabricator was Dick Johnson, a former college English professor who had the mental acuity to deconstruct the layered patterns of Elliott's design drawings and the patience, skill, and tenacity to execute them. As his health declined, Elliott relied more and more on Johnson to shape his ideas into tangible form.

It's ironic that despite his success as a public artist and his home-town celebrity, Elliott has remained relatively unknown in the broader Northwest art scene. Without gallery representation in the closest major cities—Seattle and Portland—much of Elliott's studio work has never been widely seen. The retrospective that is the subject of this monograph, *Richard C. Elliott: Primal Op*, is the first time a full, career-spanning selection of Elliott's life work has been assembled for an art museum. For many, the scope of this work will be a revelation.

NOTES

1 All quotations in this book from Richard Elliott not attributed to a specific news source or interview are drawn from his collected writing, including artist statements, public art and museum proposals, letters, and other documents held by Jane Orleman.
2 Elliott, undated artist statement, courtesy of Jane Orleman.
3 Matthew Kangas, "Into the Eye of the Beholder," *Seattle Weekly*, January 13–19, 1988: 41.
4 Robin Updike, "Mia Gallery Will Close: Had Unique Artistic Niche," *Seattle Times*, March 21, 1997; see http://community.seattletimes.nwsource. com/archive/?date=19970321&slug=2529772 (accessed January 23, 2013).
5 Jim Christy, *Strange Sites: Uncommon Homes & Gardens* (Madeira Park, BC: Harbour Publishing, 1996). Jeff Davis and Al Eufrasio, *Weird Washington: Your Travel Guide to Washington's Local Legends and Best Kept Secrets* (New York: Sterling, 2008).
6 Interview with Jane Orleman, May 6, 2013. Digital recording and transcript held by the author.
7 The Henry was expanded in 1997 and three of the niches were covered. Elliott's inserts for these were returned to the artist and are now displayed on an outdoor studio wall at Dick and Jane's Spot in Ellensburg.
8 Chris Bruce, nomination letter for Governor's Arts and Heritage Awards, October 16, 2007. Possession of Jane Orleman.
9 Chris Bruce, phone interview, January 30, 2014.
10 Lillian Stillman, "Knock-out Show Razzle Dazzles," *The Daily Record* [Ellensburg, WA], September 12, 1985: 2.
11 William Folkestad, "Two Studios, One Bed: Jane Orleman & Dick Elliott," *Highground* 3, [Fox Mountain Publishing, Pullman, WA], October 1997: 40–43.
12 According to Orleman, this was the only time Elliott didn't meet his opening schedule.
13 Telephone interview, John Olbrantz, January 30, 2014.
14 Craig Troianello, "Reflections on Diversity," *Yakima Herald-Republic*, February 27, 1993: 4BB.

RICHARD ELLIOTT (fig. 25) was the kind of guy who could fill a room. Mindful. Intense. Competitive. Fearless. Obsessive. Uninhibited. Optimistic. Disciplined. Relentless. Ready—as one friend put it—to eat the world alive.[1]

Growing up, Dick wasn't much of a student. He had to work hard at everything. Reading thwarted him, and he was shuttled into remedial classes that didn't help. A high-energy boy who had trouble sitting still, Dick would be diagnosed with dyslexia and attention deficit disorder today, says his brother Jim, who suffered from the same problem. "When we were growing up they just called us squirrelly."[2]

In fifth grade, Dick had his first real exposure to art when he was given some clay and shown pictures of classical Greek sculptures. It was a revelation. "Men made those sculptures and I'm going to be a man," he thought, "so I can be an artist."[3]

Dick was born in Portland, Oregon, where his father, Jenkin Elliott, sold office equipment and his mother, Marian, ran the house and kept track of four children (fig. 26). The oldest, Mary Georgina, came along in 1942, Richard in 1945, James in 1948, and Thomas (now Hari Nam Singh) in 1951 (fig. 27). When the kids got older, Marian—kind and supportive—took a job as the secretary at the United Methodist Church. Jenks, who served in the Navy during World War II, was a good dad: a successful businessman and sports enthusiast who instilled his competitive nature in the boys. He began volunteering as a baseball coach before his sons were old enough to be on his teams and all three of them eventually played under their dad's guidance. He expected them to excel.

Sports Dick could understand, but school remained a constant frustration for him. He'd tell his mother he felt sick in order to stay home. That happened often enough so that on a day when Dick's class was scheduled to demonstrate square dancing on a local TV show and he complained of illness, Marian made him go anyway.

35

Figure 25
Dick Elliott, 1993.
Photo: Jane Orleman.

Figure 26
Jenks and Marian, Dick's
parents. 1959. Photo:
Richard C. Elliott Estate.

Figure 27
The Elliott children,
left to right: Dick, Mary
Georgina, James, Jenks
(father), and Thomas
(now Hari Nam Singh),
early 1950s. Photo:
Richard C. Elliott Estate.

"She thought he didn't want to do that dancing," Jim remem-
bered. But as she watched the TV show, Marian could tell some-
thing wasn't right with her son. She jumped in the car, picked him
up at school and drove straight to the doctor. Dick's appendix was
removed that night, right before it ruptured.

Another handicap Dick faced was his September birthday, which
made him the youngest and one of the smallest kids in his class.
He learned to compensate. When he was in third grade the family
moved to the upscale Portland suburb of Lake Oswego, where
Jenks installed a tetherball in the back yard of the house. Dick
spent hour after hour alone in the back yard, pounding that ball
(fig. 28). By the time he was in fourth grade, Dick was the school
tetherball champion in a K-6 school. That summer, on vacation
with the family at church camp, he took on all challengers, from
high school kids to thirty-year old men. The little fourth-grader
beat them all.

Athletics became Dick's way of proving himself—even though it
took a toll on him. His brothers remember him in ninth grade com-
ing home from football practice looking beat up. "He was aggres-
sive enough and competitive enough to get in and do what it took,
but he was probably twenty pounds lighter than most of the kids,"
Jim said.

In high school, Dick lettered in football, basketball, baseball, and
tennis, and was captain of the basketball team. In the evenings

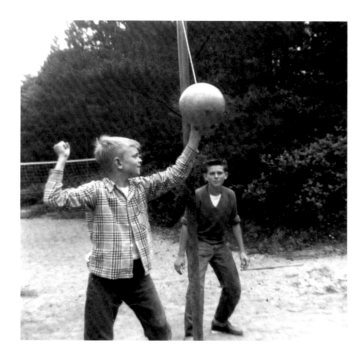

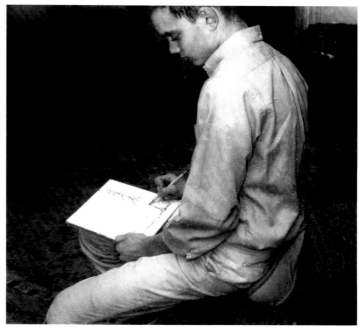

at home he showed his take-charge, creative nature by inventing games to play with his siblings. Above a doorway in the hall, he improvised a "hoop" from a coffee can lid, and the kids would toss a ping-pong ball for their own brand of miniature basketball. Their father had installed a pool table and a ping-pong table in the base-ment, which the Elliott clan kept in constant use. Later, when Dick and Jim were in college, they both carried ping-pong balls in their pockets, Jim recalled. "We were always looking for someone to play ping-pong with."

Sports and competition were one way for Dick to please his father and build self-esteem. But, like many creative young people, he had an inner life he didn't talk much about. As he made his way through high school he became something of a loner. He didn't hang out with his classmates after school and didn't bring home girlfriends for the family to meet. He signed up for an art class and one old snapshot captures the teenager at home, totally engrossed in his drawing—a glimpse into the person he would become (fig. 29).

Dick graduated from Lake Oswego High School in 1963 and was then accepted to Central Washington State College (now Central Washington University) at Ellensburg (fig. 30). Neither of his par-ents had gone to college and, with his dyslexia, Dick didn't seem like a natural candidate either. He later remembered being told he had only a ten-percent chance of making it through the first year. That was the kind of challenge Dick understood. He'd heard that

Figure 28
Dick playing tetherball, 1957. Photo: Richard C. Elliott Estate.

Figure. 29
Dick drawing at home, late 1950s. Photo: Richard C. Elliott Estate.

if you studied two hours for every hour in class you would do well, so he threw himself into his homework, combing through his textbooks over and over again until he made sense of them.

His brother Jim, now a successful Portland CPA, understood just how Dick felt: "Like a typical dyslexic, you have this inability to read, which is [one] part of the brain, but it doesn't mean other parts of the brain aren't exceptionally bright. Being put down as a bad reader for so long, it took Dick a long time to realize he was as bright as he was."

During his first year at Central, through sheer determination, Dick had been able to improve his reading comprehension. He brought home a report card of As and Bs. Even so, spelling remained a huge problem. In a short two-page essay, he might have a hundred forty misspelled words, sometimes with the same word spelled three different ways. He slogged through a remedial English class, barely passing, and would continue to struggle with composition throughout college. Dick later liked to tell the story of taking a bluebook exam and getting it back with fifty misspelled words circled in red. Despite that, the professor gave him an A plus for the essay's content.

After Dick had established to himself and his parents that he could do well, he let his grades slip. Cs and a D began to appear on his transcript, and sometimes he'd withdraw from a class to avoid failing. One former classmate remembers Dick as a good student

who didn't get good grades, someone who stood out for an almost uncanny ability to focus, a kind of zenlike mindfulness.[4]

Central Washington State College was a happening place in the 1960s, with a vibrant intellectual scene that sparked Dick's natural enthusiasm. A series of symposia on campus brought news-making intellectuals to speak and interact with students, among them the research psychologist and LSD champion Timothy Leary, philosopher Alan Watts, architectural theorist Paolo Soleri, and spiritual leader Ram Dass, author of *Be Here Now*. In the art department, professor William Dunning (1933–2003) a persuasive thinker and author, befriended Dick and helped guide his academic career. Sarah Spurgeon (1903–1985), who taught painting and drawing, was a tough taskmaster who mentored so many students that the college art gallery eventually was named in her honor. Printmaker John Agars was a longtime faculty member. Also passing through the college art faculty in the mid-sixties were Ramona Solberg, the doyen of Northwest jewelry art (followed on the faculty by jewelry artists Don Tompkins and Ken Cory), and the Northwest abstractionist Paul Heald. Another art student at Central in those days, Charles Stokes (1944–2008),[5] would become a prominent Seattle artist and teacher.

Still, the university system wasn't a natural fit for Dick's unusual learning style and there were other stresses weighing on him as well. It was the Vietnam era and Dick was a leader of the antiwar movement on campus. Schoolwork sometimes took a backseat to the life-and-death issues facing draft-age young men across the country. One day, in a fever of anxiety, Dick took the bus home to Lake Oswego to have a serious conversation with his parents. He had decided to leave school and become a VISTA volunteer, with its promise of travel and helping people in need. It was one of the formative decisions of his life.

Volunteers in Service to America—based on an idea of President John F. Kennedy's—was founded in 1965 and promoted as a way for the United States to help fight poverty through education, eco-nomic opportunity, environmental stewardship, health issues, and disaster relief. Dick signed on and was sent to Alaska to live in the small Eskimo village of Pilot Station. Some 430 miles northwest of Anchorage by air, Pilot Station was then home to about 250 Native people, many of whom didn't speak English. The little outpost on the Yukon River, some 80 miles from where it joined the Bering Sea, qualified as one of the poorest places in the nation. Dick's assignment was to help integrate the Indigenous people into the

white education system and way of life. With his usual fervor, Dick soaked up his training and set out to do that.

In his first letters home, he repeated the prevailing doctrine on assimilation: the Eskimo culture was no longer viable and the best way to help the Natives move forward was to bring them into the mainstream as quickly as possible. Dick lobbied his parents to raise money through their church to bring several Eskimo teenagers to Lake Oswego to attend high school. "Some will not even now how to take a shower," he warned, with his usual eccentric spelling. "Alot of the people here have never seen a car except in movies, so it will be strange for them."[6]

Within a few weeks, though, Dick's notions of Native culture reversed. He had discovered that the Eskimo way of life was practical, spiritual, creative, and admirably suited to their place on earth. They knew how to make all the things they needed to survive, from functional clothing for subzero winters, to superbly crafted dog sleds, fishing gear, and hunting tools. Trying to make the Inuit adapt to a different way of life, Dick realized, would be more beneficial to the U.S. government than the Native people. "The more and more I get to know them the less and less I understand them," he wrote in a letter to his family. "[I]ts so easy to just see the false similarities between our culture and theirs and miss the real complexities of their culture. I'm just beginning to sense the complexities, and its over whelming." Anyway, he concluded, "you learn more here than probably any were else."

Among the skills Dick learned were ice fishing, snaring rabbits, eating moose heart ("the best meat I ever ate"), net fishing on forty-eight-hour shifts ("backbraking work"), driving a sled for an hour and a half over rough terrain in minus-20 degree weather ("caught a humdinger of a cold"), playing Scrooge in the Christmas play ("the most fun") trekking a quarter mile to get water and foraging for miles through the woods every day for firewood ("doesn't appeal to much to my lazy nature"). He also noted "My Eskimo dancing is getting a little better."

As his brother Jim later recalled: "Basically it seemed like the Eskimos were teaching him how they lived. He wasn't doing much to teach them how to live in American society."[7]

One story Dick liked to tell was how he was out on a boat with some Eskimos, far from the village on a bitterly cold day, when the engine broke down. Rather than cursing or panicking, imagining their demise on the icy waters, his companions calmly took apart

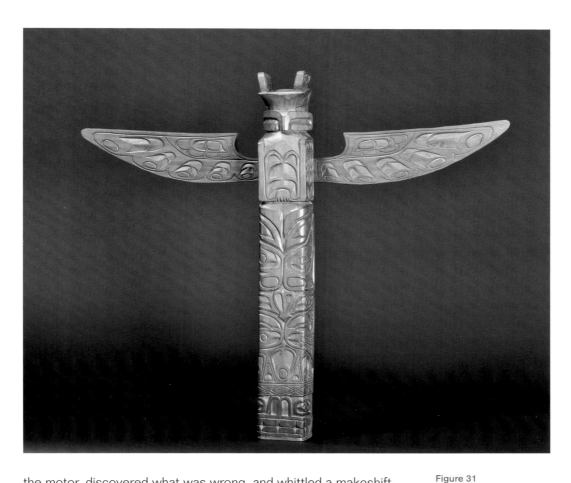

Figure 31
Carved Thunderbird
totem pole, given to Dick
by Makah artist Frank
Smith.

the motor, discovered what was wrong, and whittled a makeshift part that would get them back to safety. That was a life lesson Dick never forgot. He was the kind of guy who would just whittle a new part.[8]

When his year in Pilot Station was over, Dick transferred to Northwest Washington State where he worked with the Makah Indians. A carved Thunderbird pole, given to him during that time by the Makah artist Frank Smith, would remain among Dick's treasured possessions throughout his life (fig. 31).

By the spring of 1968, Dick was back at Central Washington, enrolled in art classes—and once more placed himself smack in the center of antiwar protests on campus (fig. 32). On the steps of the student union building, he burned his draft card, an act reported in the local newspaper. Then, in a deliberately provocative move, Dick mailed the ashes along with the news story to his draft board.

Every evening the television news broadcast terrible images of the war, and the pressures of the draft, parental expectations, college coursework, and social unrest were taking a toll on young people. One of Dick's fellow campus draft resisters committed suicide; another had a nervous breakdown. After winter quarter,

42

with failing grades in economics and English, Dick withdrew from school and in March 1969 returned to Oregon. Now it turns out he left Ellensburg just a week before a young transfer student named Jane Orleman arrived in town. Students kept asking her if she knew Dick Elliott and when she answered no, telling her: "Well, you should."[9]

Back in Lake Oswego, Dick was called in by the draft board and filled out paperwork as a conscientious objector on nonreligious grounds. He later told his brother Jim that a government representative asked him, "What are you going to do if we draft you? Are you going to Canada?" Dick coolly replied: "Why don't you do it and find out."[10]

The issue never came up. Although Dick's application for CO was turned down and he was classified 1-A, for some reason he was never called up.

After a year off from school, working for United Cerebral Palsy in Portland, and no doubt with some urging from his parents, Dick made up his mind to finish college. This time around, instead of being the youngest in his class, as he had been when he started, he would be older than most, with an experience of the world that set him apart.

His friends in Ellensburg were excited about Dick coming back. On campus, he had a reputation as someone special, with the kind of

energy and charisma that drew people in. With his intense, wide-spaced, wolflike blue eyes beneath a fringe of dark hair, he looked like "a skinny James Cagney" to one friend.[11] When Dick pulled into town on the train, his former roommate Bob Boyd picked him up and drove him over to Jane Orleman's place. "The two were such a natural fit," Boyd recalled. "In my mind they already knew each other."[12]

The meeting was a flop. Dick just sat there in his ragged clothes and didn't say a word. "I was not impressed," Jane recalled.

Still, Jane liked his looks. There was something about Dick's wildness that appealed to her. He must have found her attractive, too, because it wasn't long before Dick showed up at Jane's door again and asked if she would like to go out and draw. She was baffled. "I draw in the kitchen," she told him. That was okay with Dick. They sat in the kitchen and worked on a drawing together, doodling whatever came into their heads, until that shared act of creativity worked its enchantment. "There was some deep connection that didn't really have a question to it," Jane recalled. "Complete acceptance, comfort, excitement. No question."

Three weeks later Dick went home to pick up some clothes.

Dick graduated in June of 1971, then he and Jane got married, and she finished her degree at the end of summer quarter. Convinced that he needed to be a traditional breadwinner, Dick signed on as a salesman for his father's Portland firm, Business Machine Company. Jenks put him through a sales training course and Dick was good at it. He often ended up working sixty-hour weeks. At home, he would do some drawing, but Jane found their suburban lifestyle stifling. It was hardly the artists' life they had envisioned together. Pressure built, and after about a year Jane woke up one morning in tears. Dick looked over at her, slapped his hand to his forehead, and said: "We've got to get out of here." A half hour later he'd quit his job and by noon they were hosting a yard sale.

In the carefree spirit of the times, they decided they would trek across country to Maine and see what came of it. To speed them on their way, Jim Elliott drove them to the outskirts of Portland and dropped them off. Following the railroad tracks east and camping along the way, Jane and Dick made it about a hundred miles to Biggs Junction before—tired, blistered, thirsty, and bedraggled—they realized they were still a very long way from Maine. "It dawned on us," Jane said, "the whole plan was impractical."

They hitchhiked to the Tri-Cities and, after some discussion, headed back south. In the small agricultural community of Madras, in Central Oregon, they found a funky farmhouse for rent and—free as migrating birds—lighted there for the summer, with Dick and Jane taking odd jobs: painting signs, driving a bulldozer, quarrying rocks, harvesting potatoes, whatever needed doing. They stayed on as the leaves turned gold and a concerned neighbor advised them they had better start getting in a lot of firewood if they were going to survive the winter. At that point, Dick and Jane sat down to seriously consider their future.

One thing was certain: If they were going to be artists, they needed to live in a town big enough so that they could find work, but small enough so they wouldn't have to work all the time. For Jane, that meant Ellensburg, which felt like home to her. Dick was willing to give it a try.

Back in their old college haunt, they camped out in a rental house and Dick took a job selling used cars. He had a knack for it and did pretty well for a while. But the gas crisis of 1973 left people lined up at filling stations unable to buy fuel. Car sales plunged. To fill the time spent sitting around waiting for customers, Dick worked his way through four pithy volumes of John Canaday's art history text, *The Lives of the Painters*, spanning the Late Gothic through Postimpressionism. At home, Dick began drawing again. When word got out at the car dealership that the boss was about to lay off another employee, Dick said, "I'll go."

This was Dick's first real opportunity to devote his time to serious art-making. He set about it with the kind of laser focus he applied to any challenge, working on a series of detailed drawings of interior scenes, portraits, and large-scale landscapes.

"It was never of interest for either of us to go to grad school," Jane remembers (fig. 33). "We didn't want to teach. We just wanted to make art. Be open . . . We figured it would take us ten years to figure out what we wanted to say and how we wanted to say it."

To make enough money to support their art practices they started a cleaning business, Spot Janitorial. At first they did all the work themselves and then, as their accounts multiplied, hired employees, many of them students, and quit residential work.[13] Dick's family liked to say that Spot Janitorial provided just enough income to keep the couple "independently poor."[14] It also was the start of

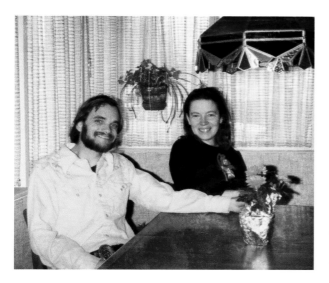

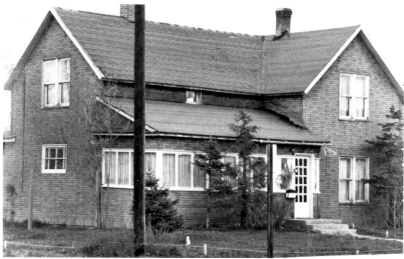

Dick and Jane's deep involvement in the community. The town was small enough that they quickly got to know many of the business owners and most of the downtown buildings and, as time went on, they stayed engaged in civic politics and city planning.

Dick and Jane began house hunting, and in 1978 they made an offer on a bleak-looking place Jane calls "the second worst house in town." Located across from the police and fire station, the drab, asphalt-shingle-sided beige/grey structure had been a haven for drug deals for years (fig. 34). City officials had considered tearing it down for a parking lot.

Even for professional cleaners, this house was daunting. But as Dick and Jane worked their way through, from the foundation up— shoring up, rebuilding, scraping, painting, plumbing, wallpapering— they also began perking up the yard. Dick brought in truckloads of topsoil and Jane put in some flowers and a rudimentary kitchen garden. To complete the storybook appeal of their new abode, Dick and Jane shared it with their blue heeler dog, Spot. They dubbed the house Dick and Jane's Spot.

At first the place looked fairly conventional from the outside. But one night Dick and Jane saw an art installation that set them on a new course. After a raucous closing party for their friend Wally Warren's show of "Hot Totems" at the John Crew Gallery in Seattle, Dick, Jane, Wally, and his then-girlfriend Marlene piled into a vehicle at three a.m. and headed back to Ellensburg. Along the way they got talking about the self-taught artist Emil Gehrke and the fantastic whirligig installation he'd created at his home near Grand Coulee Dam. They decided to go see it. Bypassing Ellensburg, they headed northeast, and a hundred and twenty-five miles

Figure 33
Dick and Jane at table, 1979. Photo: Richard C. Elliott Estate.

Figure 34
Dick and Jane's house, 1979. Photo: Jane Orleman.

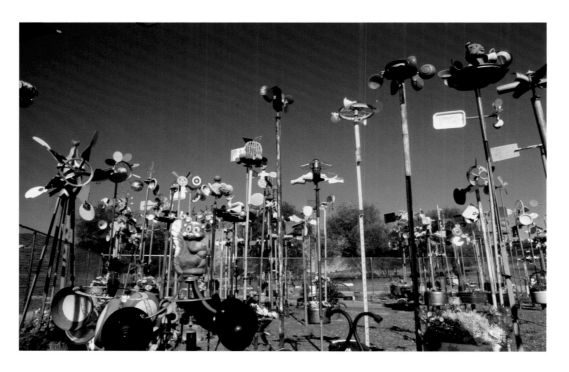

46

later entered the tiny hamlet of Electric City. In the early morning light, they came upon Gehrke's modest house.

It was an amazing sight. Dozens and dozens of oddly shaped contraptions sprouted like multicolored mechanical sunflowers all over the yard (fig. 35). Assembled from discarded bicycle wheels, coffee cups, washing machine parts, old farm machinery, pots and pans, and whatever other odds and ends of junk caught Gehrke's eye, the whirligigs fluttered and spun with each gust of wind, a miniature carnival fun forest.

Dick and Jane got fired up at the sight. Back in Ellensburg they stopped at an open-air junk store and flea market, where a lumberjack named Bud was selling some primitive log sculptures he'd carved. Dick and Jane bought one. That sad-eyed stick-man, with a big empty space where its heart should be and some kind of odd antenna protruding from its head, was the first piece of art they installed in the garden.

But their own art project was what brought them to the sale. They filled up the truck with odds and ends of lumber, old ironing boards, bicycle parts, a piece of a saddle, a boot, a Mickey Mouse doll, a discarded oil painting—every kind of makeshift raw material they could find. Enlisting Warren and Marlene and another creative couple, Dick and Jane led an all-night fence-building marathon. Funky, erratic, shapeless: not something that would meet any kind of building code or conventional sense of beauty, the fence was a hoot to build and definitely stopped passersby in their tracks.

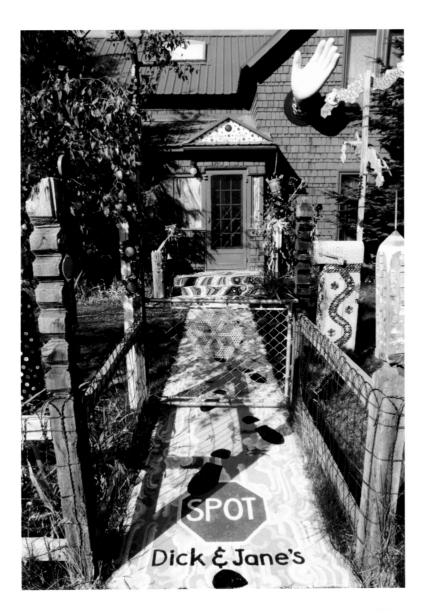

Figure 36
Entrance, Dick and Jane's
Spot. Photo: Richard C.
Elliott Estate.

"We were stoned hippies," Warren said, later, of the fence-build-ing party. "It was just fun."[15]

Keep in mind that all this is happening across the street from the Ellensburg police station. City officials as well as curious locals were keeping a close eye on the unorthodox home improvements at 101 North Pearl Street (fig. 36). Reporters for the local news-paper took note, too, and as the garden transformed they began typing out bemused but appreciative stories about the town's lat-est attraction. The "incredible hodgepodge" included some 500 tulip bulbs, surreal metal birds, a shed-wall collage of scrap metal, "an ancient wood tower," and all kinds of miscellaneous statu-ary (fig. 37). But among the garden's highlights and oddities, the reporter concluded drily, "the feature that has caused the most public comment as of late is the recently completed 'fence' in front of their home."[16]

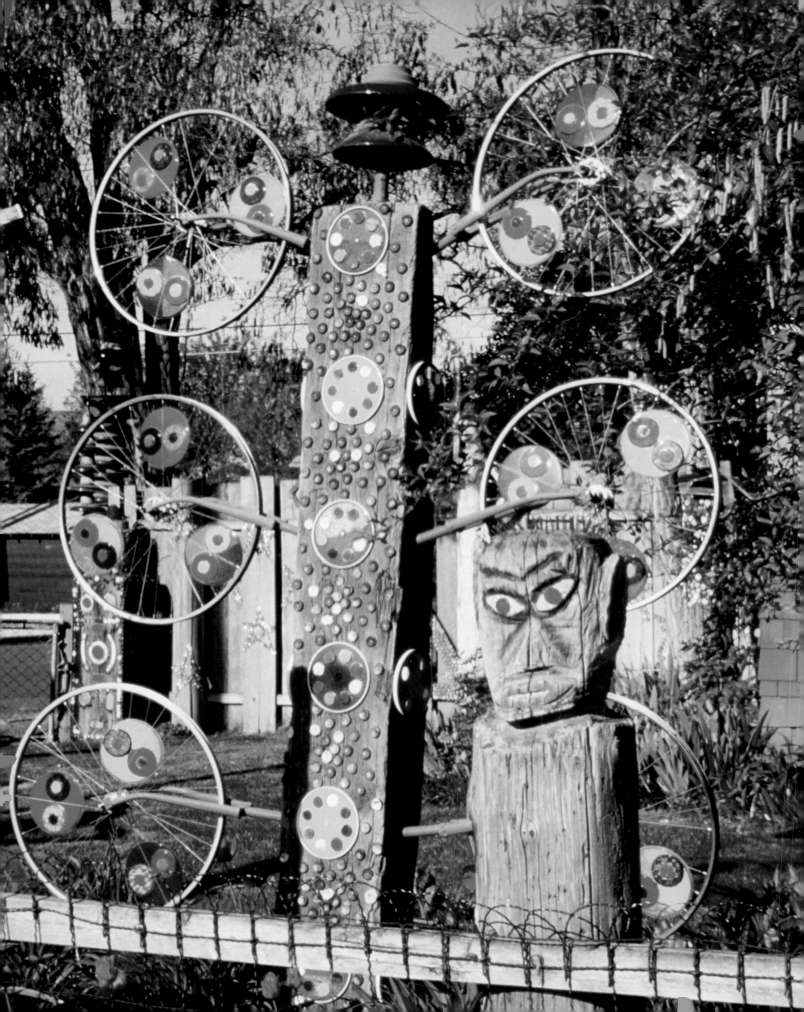

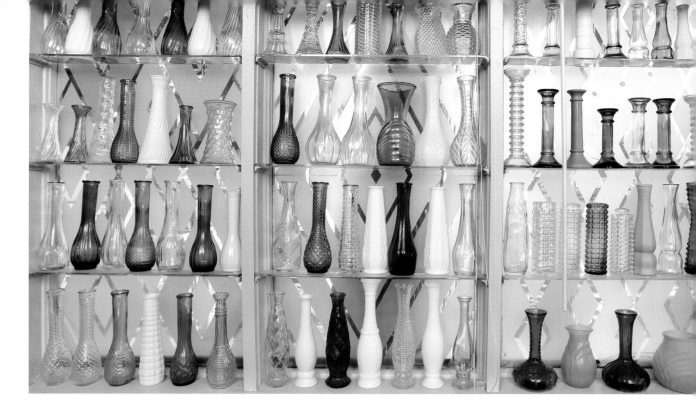

As their garden grew, Dick and Jane had fun assembling their own collections inside the house. A variety of bud vases, each different, lined the dining room windows (fig. 38). Dick got excited about the Indian-inspired designs on Pendleton vests and accumulated as many different ones as he could find (fig. 39).

The couple also began a long tradition of civic engagement, with Dick serving on Ellensburg's Downtown Taskforce for ten years (he was chairman for five), where he helped guide the town's choices for sidewalks, benches, lighting, street trees, and planters. Twice Dick ran for city council, and although he didn't win, he stayed involved in local politics, lobbying to have a new Fred Meyer megastore built close to the center of town, rather than out in the suburbs, to preserve the downtown business district.

Dick also designed and led the creation of an interactive art

VEST OF THE WEST

Clymer Museum Of Art
January 5th - February 24

416 N Pearl • Ellensburg WA 98926
509-962-6416 • clymermuseum.com
Monday - Friday 10 AM to 5 PM • Saturday 10 AM to 4 Pm
First Friday Receptions: January 5th 5-7 PM • February 2nd 5-7 PM

Figure 37
Totem and fence post, Dick and Jane's Spot. Photo: Richard C. Elliott Estate.

Figure 38
Part of Dick and Jane's bud vase collection.

Figure 39
Vest of the West poster with a selection of vests from Dick Elliott's Pendleton vest collection, Clymer Museum of Art, Ellensburg, Washington. Photo: Richard C. Elliott Estate.

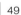

49

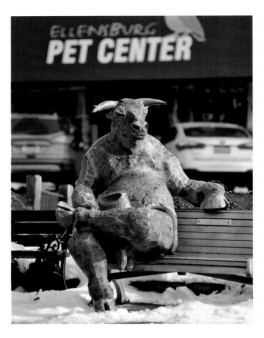

installation, *Millennium Labyrinth*, at Ellensburg's public library, built with volunteer help. And he and Jane raised money for the city's first free-standing downtown sculpture by Richard Beyer (known in Seattle for his Fremont neighborhood icon, *Waiting for the Interurban*). Beyer's cast-bronze *Ellensburg Cowboy*, like many public artworks, raised hackles at first (fig. 40). A few overly concerned citizens in the livestock and rodeo town professed to be shocked at the anatomically correct sculpture. To placate detractors, Beyer changed the name to *Ellensburg Bull*, thus eliminating any potential insult to local cowboys. Naturally, once the initial flurry of dissent ran its course, the humorous artwork quickly became a popular local landmark.

Figure 40
RICHARD BEYER
(American, 1925–2012),
The Ellensburg Bull, 1986,
Ellensburg, Washington.

Dick and Jane encouraged other public art acquisitions as well. In fact, raising funds for public artwork and supporting younger artists became part of their mission. They donated endowment money to establish an annual award for the university's student art show, now called the Dick Elliott Fine Arts Award.

As their civic work blossomed, Jane and Dick individually, in separate studios, continued to advance their own artwork. While Dick expanded his imagery from representational drawing to assemblages and reflector paintings and grand, site-specific public art installations, Jane chose an inward path. In a courageous step, she moved beyond the bright, pleasing interiors and funny/provocative yard sculptures she had been making and began using her symbolic narrative paintings to explore, through a long period of psychotherapy, the trauma of childhood sexual abuse. Those paintings, widely exhibited, were reproduced in the book *Telling Secrets: An Artist's Journey Through Childhood Trauma*, published in 1998 by The Child Welfare League of America and funded by the Paul G. Allen Charitable Foundation.

At Dick and Jane's Spot, friends were adding their inspiration to the outdoor sculpture collection, among them Warren, Beyer, the late sculptor John Harter, and former Central MFA student Reid Peterson, who made various 3-D pieces—a tin man, a wire horse, a wire man—to use as models for his drawings and paintings, and then donated the sculptures to the garden (fig. 41).

Nonprofessional artists were welcome to contribute artworks, too. Dick and Jane bought work from a postman and a local rancher.

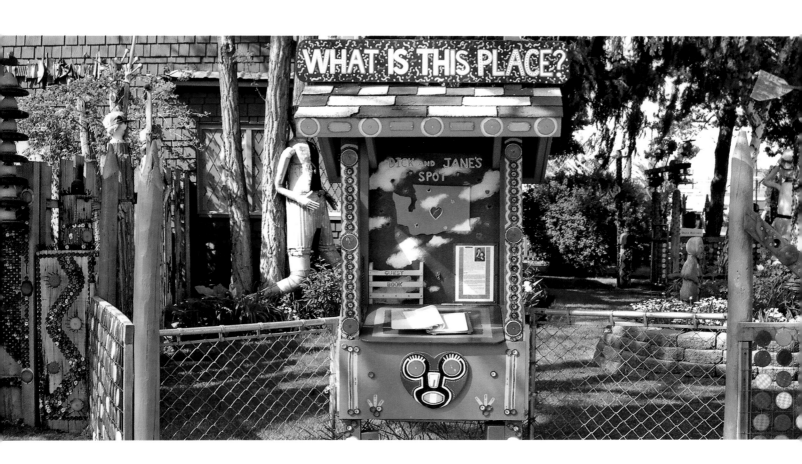

They hired an Ellensburg stonemason to build raised flowerbeds and commissioned their friend Davy Simkins to build a heart-shaped fishpond. He did such a lovely job they asked if he would like to add his own sculpture to the collection. Would he ever! For the next three years Simkins labored on an amazing twenty-two-foot tower mosaicked with assorted tiles, plumbing fixtures, and electrical parts, now a highlight of the garden. Occasionally, too, an anonymous donation would crop up during the night.

The initial junk fence is long gone. But that first all-night fence construction party set the tone for the quirky, found-art aesthetic of the place. Festooned with some 20,000 bottlecaps, countless reflectors, bicycle-wheel whirligigs, a neon-light piece, and dozens of freestanding sculptures, Dick and Jane's Spot is now a nationally known roadside attraction (fig. 42). Their fantastical sculpture garden has been featured in dozens of magazines, books, and television documentaries.[17] "The Spot," as it is affectionately known, is Ellensburg's first and most renowned piece of public art.

Figure 41
What Is This Place?, Dick and Jane's Spot. Photo: Richard C. Elliott Estate.

NOTES

1 Philip Garrison, e-mail to Jane Orleman, November 23, 2008.

2 Jim Elliott interview, Portland, November 4, 2013.

3 Elliott, quoted in an interview with Jane Orleman, September 13, 2013.

4 John Hofer interview, Salem, Oregon, November 5, 2013.

5 Stokes was the first winner of the Seattle Art Museum's Betty Bowen
 Award in 1978. He moved to New York in the early 1990s and died there
 in 2008.

6 Quotes from Dick Elliott's correspondence with his family are shown with
 their original spelling intact. The letters were provided by Jane Orleman.

7 Jim Elliott interview, November 4, 2013.

8 Hofer interview, November 5, 2013.

9 Jane Orleman interview, September 14, 2013. The following quotations
 from Jane are from this and follow-up interviews.

10 Jim Elliott interview.

11 Philip Garrison e-mail to Jane Orleman, November 23, 2008.

12 Telephone interview, February 20, 2014. Bob Boyd (now Boyd Ditter) was
 the best man at Dick and Jane's wedding.

13 Dick and Jane both worked through college doing janitorial work and
 housecleaning. Over the years, through Spot Janitorial, they gave jobs
 to some 300 students and were proud to help them finance their college
 educations.

14 Jim Elliott interview.

15 Wally Warren, telephone interview, December 18, 2013.

16 Lynn Napier-Fugate, "Landscaping: An artistic adventure," the [Ellensburg]
 Daily Record, September 8, 1980: 1. Richard Denner built the scrap-metal
 collage.

17 For more photographs, video clips, and a full list of publications, go to
 http://www.reflectorart.com/spot/ (accessed January 26, 2014).

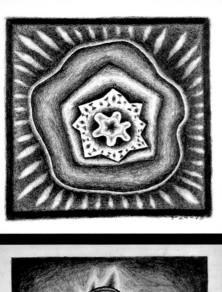

3-24-73

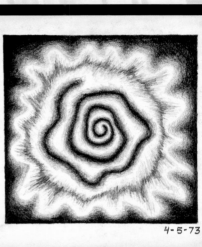

3-21-73

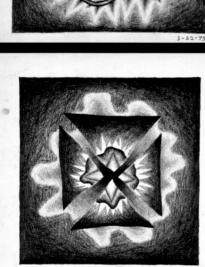

3-22-73

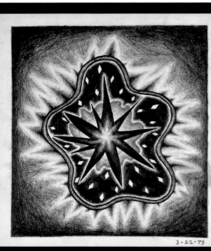

4-5-73

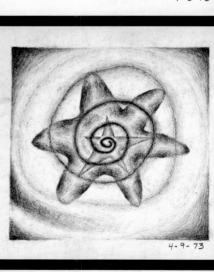

4-1-73

4-9-73

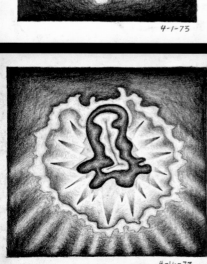

4-16-73

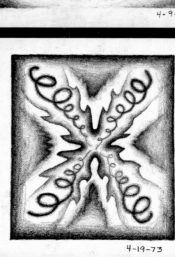

4-19-73

THE EARLY DRAWINGS

THE MOST REVEALING series of drawings Dick Elliott ever
made has been tucked away in a file drawer for decades, never
framed, never exhibited. They aren't particularly earthshaking as
individual artworks, but they point us toward all the hallmarks of
Elliott's future as an artist: a fascination with light and primal pat-
terns, a desire to explore multiple variations within set restrictions,
and a expansive sense of scale that can read as microscopic or
cosmic (fig. 43). These small, abstract graphite drawings seem to
spring directly from the artist's psyche.

The first is dated March 21, 1973. It was the vernal equinox, a
Wednesday, so we can imagine Dick coming home from work at
the Ellensburg car lot, eating dinner with Jane, sharing news of
the day, and then, with a cup of coffee in hand, sitting down to
draw. He began by marking a rectangular boundary on a 14 by 17
inch sheet of paper. Within that he located the center point, then
began building his imagery outward in arced, radiating strata, light
and dark. The layers aren't static like tree rings or soil sediments,
records of time past, but instead evoke a moment in flux, a living
cell or exploding star, pure energy and light: the force of creation.

This exploration of primal forms within a set of constraints was
Elliott's default mode. You can feel him settling deep into the
work, utterly absorbed. His intellect isn't interfering in the pro-
cess, imposing ideas about what art is supposed to be, what
might please an audience or appeal to buyers. At some point, he
knocked over his coffee cup and brown liquid splashed over the
paper. Maybe he cursed, but then smiled when he saw the effect.
The coffee marks were just another dose of energy on the page:
little explosions bursting off the surface of the sun.

Was this first drawing the beginning of a spring ritual, a way of get-
ting back in the habit of image-making? The second of the series
is dated the next day, March 22. We don't know if Elliott continued
that routine and later culled the images that didn't satisfy him, or if
he only completed the eight that exist. The last is dated April 19.

55

Figure 43
Untitled, 1973, graphite
on paper, 14 x 17 in.
each, collection of Jane
Orleman, Ellensburg,
Washington.

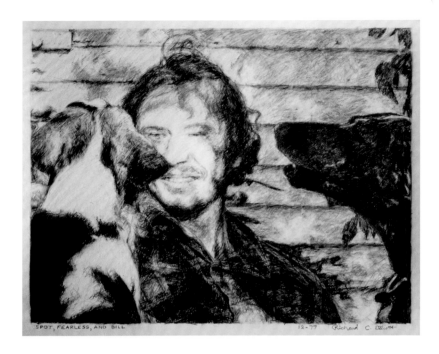

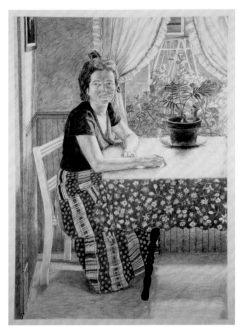

Figure 44
Spot, Fearless, and Bill,
1977, graphite on paper,
23 x 30 in., collection of
Jane Orleman, Ellensburg,
Washington. Photo:
Richard C. Elliott Estate.

Figure 45
Jane, 1974, graphite
on paper, 60 x 42 in.,
collection of Jane
Orleman, Ellensburg,
Washington. Photo:
Richard C. Elliott Estate.

For some reason, much later in life, Elliott went back and erased the dates and signatures on most of his early representational drawings. He never explained why. But on this seminal series of abstractions, he left the dates intact.

Not long after those little drawings were done and put away, Elliott made some life-changing decisions. He left his job selling cars and he and Jane started Spot Janitorial to support themselves and their creative endeavors. And he made some decisions about art as well. In his next series, instead of turning inward for inspiration, Dick looked out over the world around him. In intimate portraits (fig. 44) and thoughtfully composed interiors and landscapes, he paid homage to the people and places he loved: to Jane (fig. 45), their families and friends, and his favorite haunts. Usually based on one or more photographs, the true-to-life images showed off his proficiency as a draftsman and—unlike abstract drawings—were easily appreciated by average viewers.

Yet Elliott also was tuned in enough to art-world trends to know that photorealism was the latest buzzword. Like Chuck Close, a leading proponent of that style, Elliott had a similar kind of obsessive focus on detail, as well as the requisite patience for such a labor-intensive way of working. Perhaps there's a connection between dyslexia and a certain kind of dogged visual acuity, because Close, too, struggled with that reading disability growing up, and developed a single-minded attention to minutiae (fig. 46). Close also suffers from an inability to recognize faces, and presents his images dispassionately: close-up, head-on, aggressive,

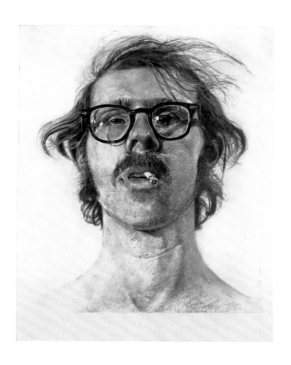

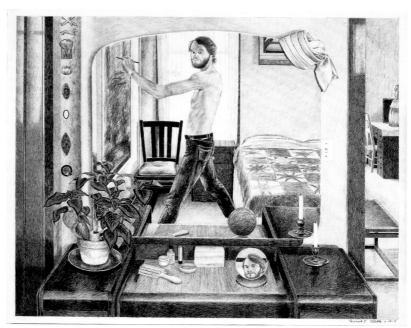

warts-and-all. They are more like intricate topographical maps than portraits. Close has said that his difficulty distinguishing facial characteristics motivated his interest in photographing and painstakingly reproducing them.

Elliott's approach to representation, however, was much different from that of Close, more infused with warmth and emotional involvement. Stylistically, however, the drawings are all over the map. *Self Portrait with Two Mirrors*, an intriguingly complicated composition of domesticity and ambiguity, shows us the artist—bearded and shirtless—at the center (fig. 47). He seems to be standing inside a window, looking out. But on closer view we see he is actually reflected in a dressing-table mirror and the bedroom scene we are looking into would be, in real space, behind us. With its multiple doorways, windows, apertures, and mirrors, the drawing is a tour de force of spacial illusion. It has some of the flavor of the California Funk movement and the trompe l'oeil surrealism in vogue at the time on rock 'n' roll album covers and psychedelic posters.

On the other hand, a 1970s portrait of Jane is more reminiscent of Renoir (fig. 48). Elliott presents his young wife in a sensual, shadow-dappled pose, her arms laden with lilacs: all blossoms, warmth, and femininity. Her face framed by a stylish straw hat, and partly dissolved amid the light-struck foliage, *Jane Picking Lilacs* (fig. 49) is Impressionism distilled to its black-and-white essence. Elliott submitted the drawing in 1980 to the 24th Annual Central Washington Artists Exhibition, the region's most prestigious exhibition.[1] It took first place.

57

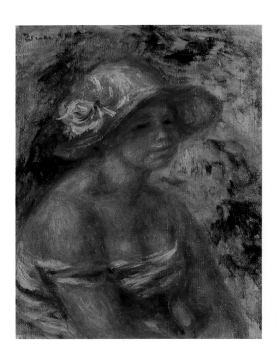

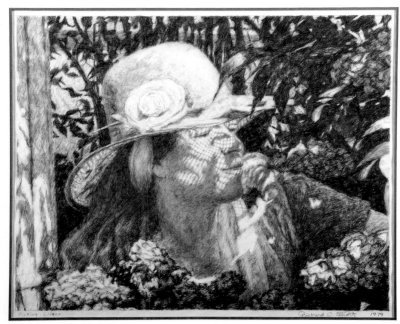

Figure 48
PIERRE-AUGUSTE
RENOIR (French, 1841–
1919), *Bust of a Young
Girl Wearing a Straw Hat*,
1917, oil on canvas,
31 x 24 in., private
collection. Photo:
courtesy WikiPaintings.

Figure 49
Jane Picking Lilacs,
1979, graphite on paper,
32 x 36 in., collection of
Jane Orleman, Ellensburg,
Washington.

Figure 50
*The Food Chain—"Buying
the Food,"* late 1970s,
graphite on paper,
47 ¾ x 90 in., collection of
Jane Orleman, Ellensburg,
Washington.

Figure 51
Upper County (unsigned),
mid-1970s, graphite
on paper, 48 x 60 in.,
collection of Jane
Orleman, Ellensburg,
Washington.

For his large-scale interior scenes, Elliott would shoot dozens
of images that he arranged and condensed into huge composite
drawings, such as the 48 by 90 inch *The Food Chain—"Buying the
Food"* (fig. 50), created in the studio in the late 1970s. Referenc-
ing snapshots, he would establish the scale and relationships of
checkout counters, signage, windows, food and news displays,
blocking out the basics of the composition. Then he aimed his lens
at individuals, looking for telling gestures, quirky clothing, hairdos,
interesting interactions. Jane, her brother, and Bob Boyd appear in
the drawing; Jane's mother appears twice. Spot is waiting eagerly
outside the window. (Spot knew the drill: His namesake janitorial
service did the windows at Safeway, so he'd hung out around the
store plenty of times before.)

For the landscapes, too, Elliott worked in a large format, seeking
to express the grandeur of Washington's Central Valley, the rich
textures of the hills, the intense high-desert sunlight and velvety
shade (fig. 51). Like traditional landscape painters, he would haul
his materials out into the hills to work. In his case that meant a
huge sheet of rag paper tacked on a plywood panel and an assort-
ment of graphite sticks. In midday, with the sun high and the light
flat, slowly, day after day, he would draft the composition. But
unlike the old plein-air painters, Elliott showed off his accomplish-
ments as a draftsman by sticking to black and white.

In 1975, for the first of his Valley Series, Elliott chose a site over-
looking the rodeo grounds, the university campus, town, and
surrounding farmland sprawled against the serrated backdrop of

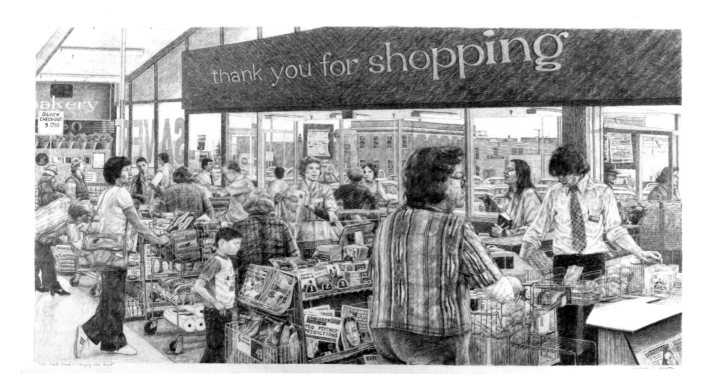

The Food Chain — "Buying the Food"

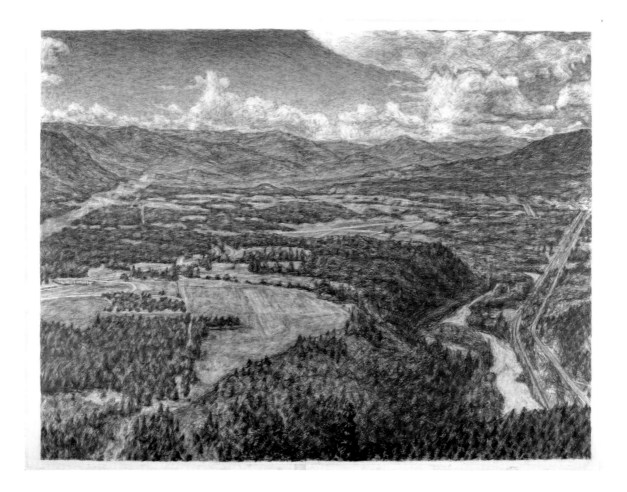

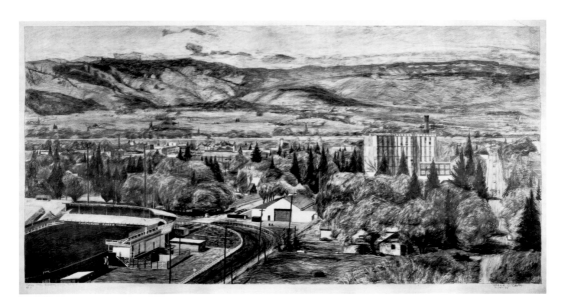

Manastash Ridge. Working in the open air and gusting breeze, the sun hot on his neck, Elliott built his landscape patiently, from the top down. Sometimes, when the wind was high, he'd be forced to stay in the back of the van and work, the doors swung open to the view. When the weather got too cold, Elliott set up his 8-foot plywood easel on the diagonal in the tight squeeze of his 7-foot-wide studio. He spent the next several months—referencing photographs as needed—shading and modulating, refining the intricate details (fig. 52). Once the 4 by 7 ½ -foot landscape was complete, Elliott titled it as precisely as he had rendered it: *Ellensburg, WA 98926*.

He'd already been planning a way to exhibit it. One thing to remember about Dick Elliott: promotional savvy was printed in his DNA. So, during rodeo week, when the town was abuzz with visitors and local pride ran high, Elliott arranged to hang the drawing in the lobby of the Ellensburg State Bank, where a steady stream of people would get to look at it. The newspaper was alerted. In August 1975, the Ellensburg *Daily Record*—ever eager for juicy local color—featured a photograph of Elliott and a bank administrator standing in front of his drawing. "It's a penciled draft of an aerial perspective on a working field which defines an image rather than implies an image," the proud artist explained in a flourish of art-school terminology. And—pointing out traces of red and green pigment incorporated in the ostensibly black and white drawing—he added, "The color is peripheral but it creates a shimmering tone that can be transferred into depth and space."[2]

As a marketing tool, Elliott had a postcard of *Ellensburg, WA 98926* printed up, advertising his series The Valley Drawings, and noted

on the back, along with his address and phone number: "All draw-ings are for sale or trade. Any reasonable offer considered."

A year later no buyer had come calling, and Elliott submitted *Ellens-burg, WA* for the 1976 Portland Art Museum's Artists of Oregon exhibit. It caught the eye of the juror, acclaimed California Funk artist Roy de Forest (1930–2007), who selected it for the show. This was Elliott's first exhibition in his hometown and he must have been gratified to have art historian Roger Hull, reviewing for the Portland newspaper, single out for comment his "arresting" drawing. As Hull astutely observed, "Elliott's scene from afar does seem almost topographically accurate, but at closer range it unrav-els in the direction of spontaneous abstraction."[3]

The Valley Drawings, the interiors and portraits, were in effect Elliott's apprenticeship: a way to hone his craft and begin formulat-ing his ideas about what art could be. But in the late 1970s he had a flash of insight that set him on a new course. He later wrote:

> My epiphany came as I was doing a landscape drawing of the Kittitas Valley. It was during the tenth session, out of an even-tual hundred, from a freeway overlook. As I began to notate impressions of the valley floor onto a large piece of paper, I settled into a hypnotic state. This particular day, a Gestalt experience of the presence of the living earth greeted me. In the deepest part of my being I felt the breath and pulse of the earth. Everything I perceived was alive and filled with con-sciousness. . . . As I looked down on our valley and saw the city of Ellensburg, the place where our daily lives played out, our mundane human concerns melted into triviality.[4]

Elliott finished his drawing of the Kittitas Valley, and then put away his graphite and gave up representational art for good. He later explained, "A new art form, with new ways of thinking about imag-ery, light, time, space, and human drama emerged."[5]

NOTES

1 The exhibition was held at Yakima Valley College's Larson Gallery. A news story about it, headlined "Elliott's Work Tops Art Show," appeared with no byline in the Ellensburg *Daily Record*, January 29, 1980, p. 7.
2 Joanne Brown, "Mainly About People," Ellensburg *Daily Record*, August 1975 (no page or complete date available).
3 Roger Hull, "Lively Creations Paper Museum," *The Sunday Oregonian* [Portland], March 21, 1976 (no page number available).
4 From Dick Elliott, "An Infinite Point in Time," 1999.
5 Ibid.

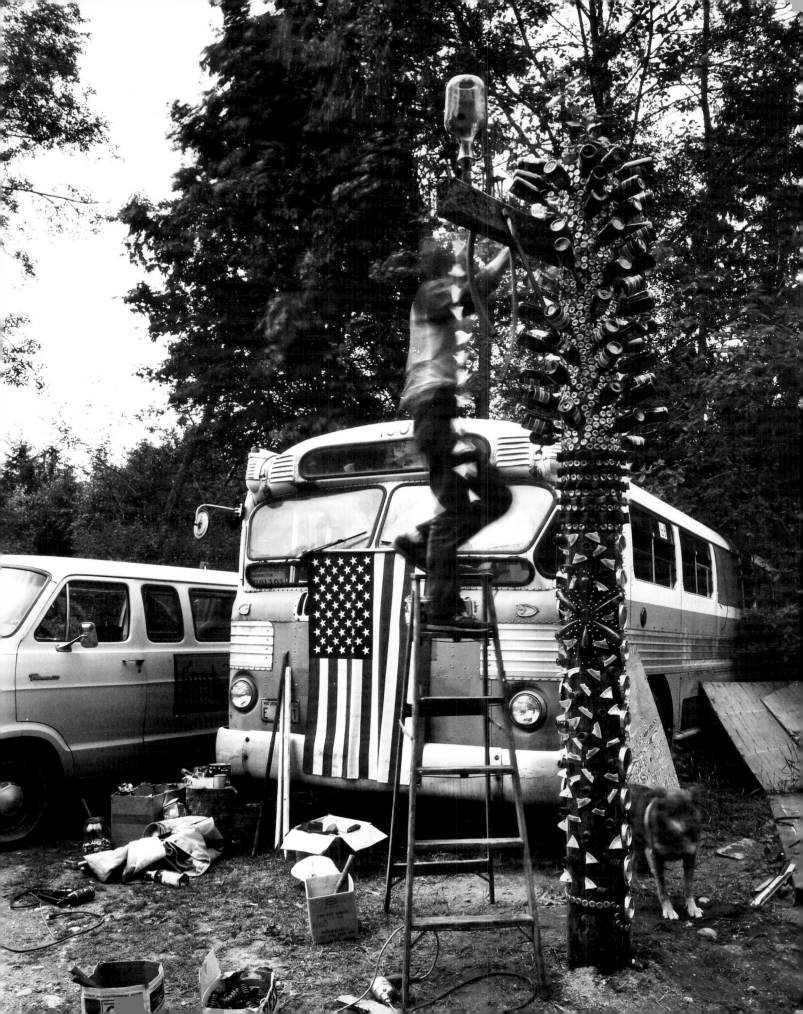

FETISHES AND FESTIVALS

ON THE MORNING of July 5, 1982, Dick and Jane awoke early on a plot of wooded acreage in the Seattle suburb of Bothell, Washington. They'd been camped out for several days already, pounding nails, gluing reflectors, assembling sculptures, and having a few beers to keep the inspiration flowing (fig. 53). That night the moon would darken in a total eclipse and preparations were in full swing for a major celebration. Dozens of guests would soon be converging and Dick, gearing up for his role as Chief Magician (aka Chief Lunatic), was the main attraction.

The site of their art show was the abode of Seattle artist John Harter—an old bus parked on a secluded bit of bog land, a place custom-made for him and his pals to party. One evening, hanging out with Harter and photographer Ken Slusher (owner of Open Mondays Gallery),[1] Dick learned that a commercial developer had his sights on Harter's property: something about an industrial park. Outraged, he demanded it be stopped. When asked how they could do that, Dick lifted a finger prophetically: "We'll do it with magic."[2]

A few years earlier Dick had experienced a mind-altering moment while working on a large landscape drawing. Since then, memories of living with Alaska Natives, their imagery and rituals, came flooding back to him as he searched for a different, more fundamental kind of artistic expression. He began to improvise with traditional tribal imagery.

Earlier in 1982, Dick had created a Magic Circle of totems and painted rocks (fig. 54) for his first Seattle group show at Traver/Sutton Gallery.[3] Some of his buddies had teased him about painting rocks, which they found kind of hokey. So Dick and Jane came up with a way to get them all involved, too. They figured if a bunch of people each created a piece of rock art, they could install them in a big outdoor exhibition and channel good juju—or at least plenty of noncommercial energy—to Harter's property. They'd call it, punningly, a Rock Festival. To add cosmic weight to the event, Dick and Jane decided to align the art happening with the upcoming lunar eclipse.

63

Figure 53
John Harter's property near Bothell, Washington, site of the 1982 Rock Festival, with Harter's bus/abode in the background and Dick Elliott atop a ladder adding reflectors to a totem. Photo: Ken Slusher.

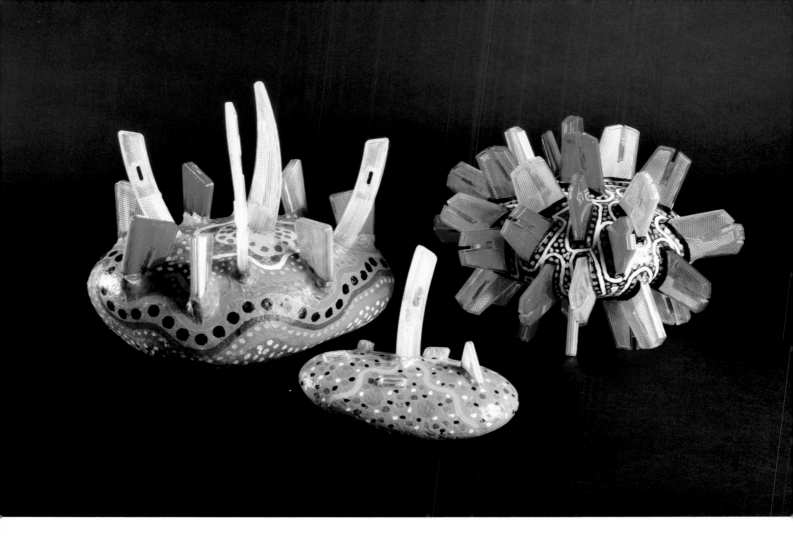

Figure 54
Painted Rocks, 1982,
rock, paint, and reflectors,
various dimensions,
collection of Jane
Orleman, Ellensburg,
Washington.

Dick's pal John Bennett, the Ellensburg poet and counterculture chronicler, immediately signed on, writing: "By the summer of 1982, we were all painting rocks. Constructing rocks. Smashing the ocean of our imaginations against rocks. Having love affairs with rocks, in the rocks, in the high desert of our minds . . . "[4]

So, now it was crunch time. Dick's *Portable Lunar Observation Piece*—six totems built from discarded banister posts and painted in bright-hued dots and squiggles, stripes and ovoid patterns—was set in place (fig. 55). He'd dotted them with colored reflectors, too—the kind he'd seen flashing on mailbox posts along the rural roads outside Ellensburg—for special lunar effects.

As Dick installed a plastic wading pool and powdered a white circle around it to attract moonlight, Harter sliced up chunks of log and set them around as sculpture stands for the rock art. Jane's contribution to the show, a curvaceous, bare-breasted pole-sculpture dubbed *Bothell Beauty*, stood at the end of the drive, marking the entrance. Guests swerved in past her, bumping along a dirt road to Harter's place, where they encountered Dick, wearing a painted

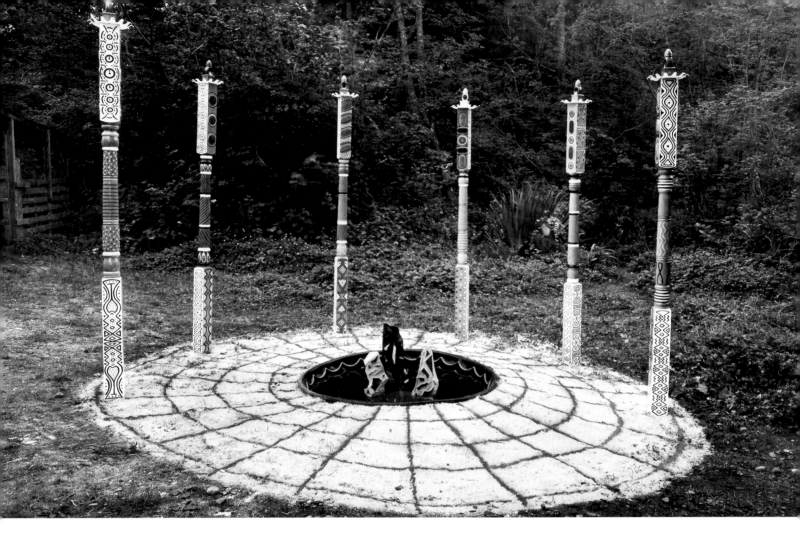

hard-hat sprouting blue and red feathers (fig. 56) and carrying on like some kind of hippy witch-doctor.

Needless to say, the eclipse celebration and Rock Festival turned into a whopping good party. Intoxicants flowed. Music blasted from loudspeakers. People danced like maniacs. Rock art in every contemporary style was admired and traded, from cheeky minimalism to a multimedia assemblage with sound effects to conceptualism.

But, frankly, memories of the main event, Elliott's Lunar Observation ritual, are hard to come by these days. Wally Warren says he remembers the party well—but isn't sure if he was there. Another artist, Cathy Schoenberg admits, "it is vivid in my mind, but when one wants to grasp the details they turn to dust."[5]

Slusher, official documentarian for the festival, jotted only a spare chronicle of the main event.

> As the participants danced around and bowed to the Lunar Observation Piece, Dick uttered more Magical incantations

Figure 55
Dick Elliott's *Portable Lunar Observation Piece* set up on John Harter's property and ready for the 1982 Rock Festival, timed to coincide with a lunar eclipse. Photo: Ken Slusher.

Figure 56
Chief Lunatic's Hard Hat,
1981, hard hat, feathers,
paint, and reflectors,
17 x 13 ½ x 21 ½ in.,
collection of Jane
Orleman, Ellensburg,
Washington.

and gesticulated in ways peculiar to Magicians. A rock band named Plutonium soon arrived to provide rock music for the Rock Festival dancers who danced more wildly as the Chief Magician in his Magic Hat gesticulated and muttered Magic mumblings into the evening.[6]

At some point sparklers were lighted and waved. A belly dancer appeared and gyrated. The moon gradually darkened (whether the sky was clear enough to see it, no one seems to recall). And the ceremony was over.

The whole festival might have faded away into murky legend, like so many artist parties of the day, except that for Dick Elliott, with his *Portable Lunar Observation Piece*, something other than the Earth and Moon fell into alignment that night. The fairy dust of sparklers, moonglow, reflectors, ritual, and a certain kind of primal patterning spoke to him in a way he couldn't yet define—but he followed the trail. A few months later Dick reprised the *Lunar*

Observation Piece for a Rock Festival revival exhibit at Open Mondays Gallery. He and Jane made spoofy hats for everyone to wear at the opening. It was all sort of tongue-in-check and fun. But at the same time Dick had serious intentions.

He never talked much about his experience living with Eskimos or with the Makah tribe, but those close to him knew it made a deep impression. He returned home from VISTA a changed person, silent and attentive. He kept his eyes downcast in groups of people, as he'd learned at Pilot Station. He even talked differently for a while, in the terse Pidgin English of the Eskimos. He'd gone Native.

Gradually those mannerisms disappeared. But in 1980, as Elliott's experience of Native culture began percolating back into his consciousness, he wrote, "the subtle influence of this experience awoke in such strength that it caused a major stylistic change in my art."[7]

The fervent intensity of outsider artists spoke to him, too, and Elliott began making pilgrimages to see their houses and outdoor installations in Washington and beyond. One summer he and Wally Warren set off on a "vision quest" to Nevada to find the World War II veteran and self-styled artist/shaman Frank Van Zant (1920–1989), known by the name Chief Rolling Mountain Thunder. They found a strange, rambling, five-acre compound with tangled wooden towers, rocks sprouting human faces, phantasmagorical swooping structures and bottle constructions, interspersed with sculpted human figures.[8]

The compulsive creativity of artists like Van Zant and Emil Gerhke, with his windmill garden, inspired Dick. So did the sweeping landscape installations and wrapped architecture of the art-world iconoclast, Christo. You couldn't always fathom intellectually what these artists were about, but the work felt awe-inspiring and inclusive in a way that much mainstream art didn't.

Even in the commercial bubble of the New York gallery scene people were hungry for a different kind of art experience. The pared-down sign language of Keith Haring (fig. 57) and the explosive, graffiti-rooted mark-making of high-school dropout Jean-Michel Basquiat signaled a kind of neo-tribalism. Ritualistic performance art was cropping up in galleries and on the streets. The German artist Joseph Beuys adopted the persona of a shaman and dubbed his performances "actions." In 1988 a show called *Dreamings: The Art of Aboriginal Australia* caused a

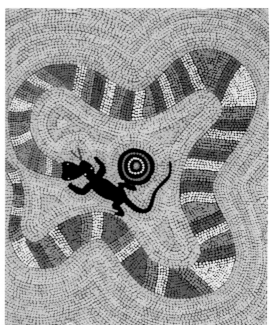

Figure 57
KEITH HARING
(American, 1958–1990),
Untitled, 1982, enamel
and Day-Glo on metal,
72 x 90 ft., © The Keith
Haring Foundation. Photo:
Untitled © Keith Haring
Foundation. Used by
permission.

Figure 58
TURKEY TOLSEN
JUPURRURLA (Pintupi,
from Kintore/Papunya,
Northern Territory,
1938–2001), *Children's
Python at Tilpakan,* ca.
1980, acrylic on board,
20 x 15 ¾ in., collection
of the South Australian
Museum, Adelaide,
A65339. Photo: South
Australian Museum,
Adelaide.

Figure 59
Spirit Dancer, early
1980s, wood, paint, and
glitter, 67 ¼ x 48 x 22 ¼
in., collection of Jane
Orleman, Ellensburg,
Washington.

sensation when it opened in New York and the imagery reverber-
ated through the art magazines (fig. 58). All of this was in the air
and Dick absorbed it (fig. 59–60).

It was during this time that Dick and Jane turned their house and
garden into a festive, evolving outdoor gallery, in the style of folk
art. "It was a way for us to interact with viewers without the filter
of a gallery or a museum," Jane said. "One of the things I always
loved about it is that the kids in this town know that an artist is
something they can be. It makes art a living thing."[9]

For Dick, this was a period of transitions and exploration. That
included a lot of partying with friends on both sides of the Cas-
cades. One night, after he and Jane wandered home from a party
across town rapt in the hallucinogenic visions of LSD, Dick awak-
ened with his head teeming with images. He sat down to a new
a series of drawings. On 8 ½ by 11 inch paper, he marked out a
6-inch square and, using a black felt-tip pen, began to unveil the
geometric possibilities within it, using only dots and lines. The
first was a simple labyrinth. The second, expanding squares within
squares. By the third drawing, overlapping squares blossomed
into multifaceted architectures, each line shadowed with dots.
Dick kept on, variation after variation, sheet after sheet of paper,
day after day, noting the date on each one. He started on January
23. On May 10, when he reached 127, he was done (fig. 61). He
boxed them up and titled the set: *127 Meditations by Dick Elliott.*

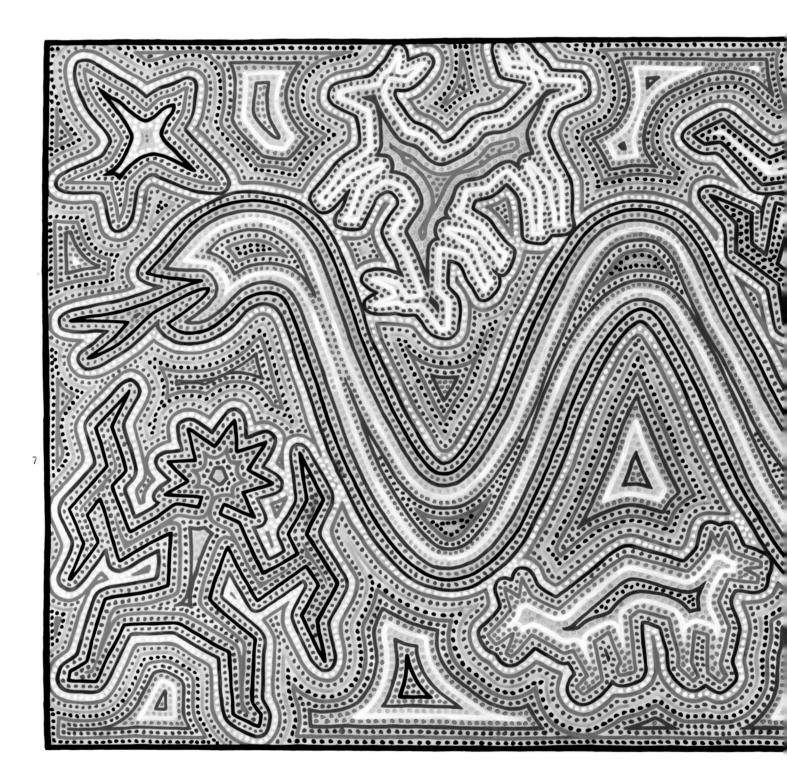

7

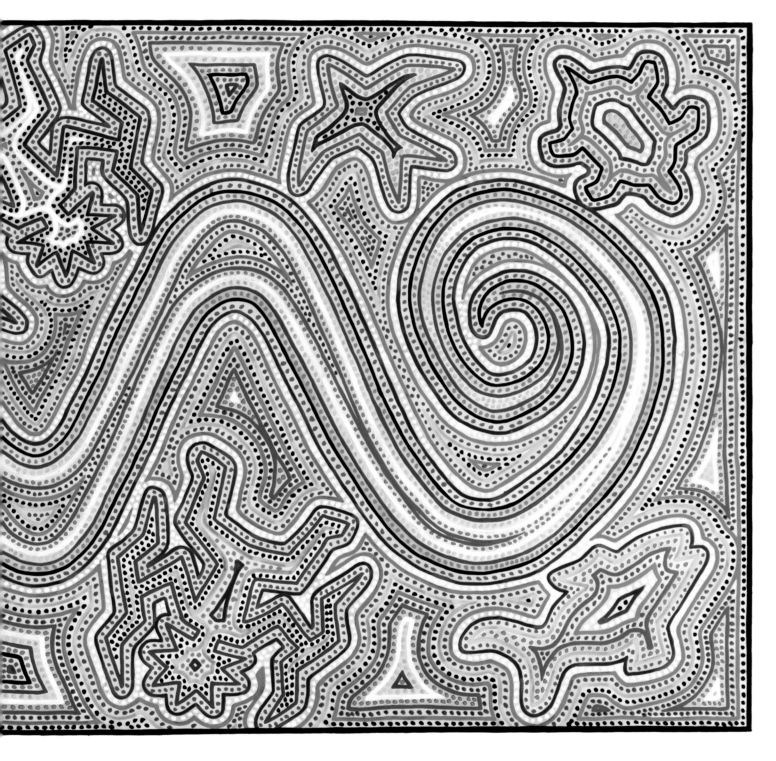

Figure 60
Snake Dance, 1984,
acrylic on paper, 47 ¾ x
96 in., collection of Jane
Orleman, Ellensburg,
Washington.

Figure 61
127 Meditations (box set), 1983, black and white prints, 8 ½ x 11 in., collection of the Hallie Ford Museum of Art, Willamette University, gift of Jane Orleman, 2014.004.

Figure 62
FRANCIS CELENTANO (American, born 1928), *Elliptical Series C: Black on Gold,* 1967, monoprint on colored illustration board, 28 in. (diameter), collection of the artist, Seattle, Washington, through the courtesy of the Loretta Howard Gallery, New York. Photo: Francis Celentano.

Talk about hallucinogenic! The images pulse and vibrate when you stare at them: The proximity of dots and lines creates a dizzying optical effect. For those prone to migraine, this might be a trigger. It's certainly enough to cause a bit of queasiness if you look too long. This was the kind of effect the Op artists of the 1960s had been investigating, and their spiraling, throbbing, eye-popping imagery took hold in a short-lived art movement that fit the psychedelic mood of the era (fig. 62). Dick understood the appeal. Now, where to go with it?

Elliott had a term for what he was doing. He called it "intuitive groping."

It was a time of appropriation and imitation. He dove into a cycle of multimedia paintings that were related in spirit to the totems and fetishes of his *Portable Lunar Observation Piece*, but based in the craftsmanship and polish of his academic training. In paintings such as *Medicine Hut* (fig. 63) and *Winter Moon* (fig. 64) Elliott finally hit his stride, composing dramatic, rhythmic designs, studded with reflectors, mirrors, nails, feathers, and glitter. In short order, he would refine those images further, to their essence.

Everything he wanted to achieve, he realized, could be done with the lightshow sparkle of Sate-Lite reflectors.

NOTES

1 The Seattle gallery operated on Roosevelt Way, near the University of Washington, between 1978 and 1984.
2 Ken Slusher, unpublished notes on the Rock Festival. Courtesy of Ken Slusher.
3 The Traver Gallery opened in Seattle's Belltown neighborhood in 1977, and for a short time was called Traver/Sutton Gallery. The Traver Gallery is now located at 110 Union Street, Seattle.
4 John Bennett, "Black Moon," *White Paper #6* (Ellensburg, WA: Vagabond Press, 1983).
5 Wally Warren, phone interview with author, December 18, 2013. Cathy Schoenberg, e-mail to author, December 20, 2013.
6 Slusher, Ibid.
7 Dick Elliott, grant application narrative, courtesy of Jane Orleman.
8 An odd, troubled personality, Van Zant was sometimes harassed and his artworks vandalized. Nevertheless, he was named 1983 Artist of the Year by the State of Nevada. In 1989, Chief Rolling Thunder killed himself with a gunshot to the head. His property is listed on Nevada's register of historic places; see www.onlinenevada.org/articles/chief-rolling-mountain-thunder (accessed March 2, 2014).
9 Jane Orleman, telephone call, February 10, 2014.

Figure 63
Medicine Hut, 1983, paint,
reflectors, wood, feathers,
and nails on canvas,
55 x 55 in., collection of
Jane Orleman, Ellensburg,
Washington.

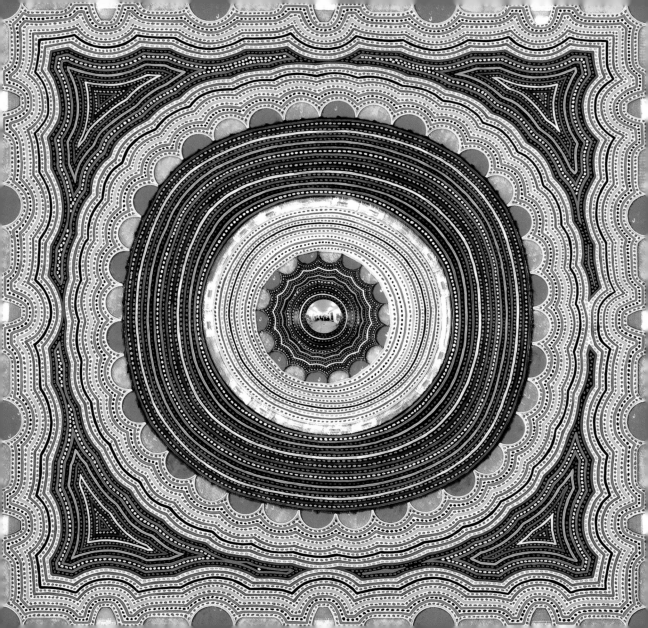

It seems that a noble and active mind blunts itself against nothing
so quickly as the sharp and bitter irritant of knowledge.

Thomas Mann
Death In Venice

IN 2006, Dick Elliott was going through some old papers when he came across a black-and-white drawing he'd made for a 1988 artist calendar (fig. 65). The pulsating lines of the geometric design fired his imagination. For the past twenty years, Elliott's primary medium had been reflectors, arranged with a layering technique he pioneered and patented. Now he was ready for something different. After some preliminary studies, he and an assistant stretched up some huge canvases. Elliott picked up a paintbrush and set to work.

The first years of the new millennium had been almost preternaturally productive for Elliott. As he continued to design and install large-scale, site-specific public art commissions—at universities, libraries, transit stations, an airport—he was at the same time working obsessively in the studio. His fascination with delineating every permutation within a set of possibilities had led him from his latest series of reflector panels *120 Color Combinations*—a 12 by 41 foot installation of 120 individual mosaics, each a reconfiguration of the five reflector colors—to an ambitious group of related prints, composed on a computer (fig. 66).

The *Eidetic Variations*, 13,275 gradated designs, are realized in grid-form in 185 laser prints, each with 72 individual images presented sequentially (fig. 67). The patterns are built from a central point in radiating arrangements of red, green, gold, blue and white dots.

Elliott's intent was to map out every possible variant. The philosophical term *eidetic*, referring to an exceptionally detailed recollection of visual imagery, perfectly fit Elliott's exploration. He installed the prints in a 2006 exhibition at the Larson Gallery at Yakima Valley College, where, two-deep, they wallpapered the gallery in overwhelming complexity.

Now, after that computer-assisted tour de force, Elliott was turning back to the low-tech medium of paint on canvas and the original sources that had fueled his work since the early 1980s: primal

77

Figure 65
Artist Calendar, 1988, ink marker on paper, 6 ½ x 8 in., collection of Jane Orleman, Ellensburg, Washington.

Figure 66
120 Color Combinations,
2005, digital print on
canvas, 39¾ x 33 in.,
collection of Jane
Orleman, Ellensburg,
Washington. Photo:
Richard C. Elliott Estate.

Figure 67
Eidetic Var...
digital print
33 ¾ x 17 in...
Jane Orlem...
Washington

patterning and optical illusion (fig. 68). This time, Elliott put a name to it: *Primal Op*.

He knew that the roots of "optical" art stretched back to early modernism: from Impressionism to the early abstractionists—Malevich, Mondrian, Albers. But it was in the early 1960s—the years when Elliott began studying art in college—that a short-lived movement burst onto the scene under the buzzword Op art.[1] A Museum of Modern Art exhibition, *The Responsive Eye*, assembled prime examples by European and American artists in 1965. The show traveled to the Seattle Art Museum.

It was a convergence of optical science, psychology, color theory, and psychedelics, custom-made for the hallucinatory decade whose guiding light was former Harvard psychology professor Timothy Leary. Leary championed LSD as a means to expanded consciousness, and on a visit to the Central Washington State College campus in 1963 his message had left a deep impression on Elliott. But in the mid-eighties, after a period of youthful partying and experimentation, Dick and Jane gave up alcohol and other intoxicants. As Jane later explained: "We had too much work to do."

Elliott's *Primal Op* paintings of 2007 carry a distinctly retro, mid-twentieth-century resonance, but this time with the broader perspective of experience. "These designs, echoing the patterns within us, have connected people to the living fabric of life since the dawn of time," he wrote, "reflecting nature on both the macro and micro levels." His encompassing 9 ½ by 18 foot painting *Primal Op* (fig. 69) taps into the same archetypal source as the transcendent 2002 painting *Leaves*, by the Australian aboriginal artist Gloria Tamerre Petyarre (fig. 70). Both artists depict energy rather than matter. Both inspire a sense of the infinite.

While he worked on the Primal Op paintings, Elliott was also engrossed in a series of computer drawings of labyrinths, age-old symbols of pilgrimage, prayer, and meditation (fig. 71).

Then, on September 17, 2007, two weeks after his sixty-second birthday, Elliott was diagnosed with pancreatic cancer. As his physical strength declined, Elliott was no longer able to paint and transferred his production onto a computer. "If I feel good enough to sit in a chair," he wrote, "I can work."

The glorious, uninhibited color patterns of the *Vibrational Field* series emerged as Elliott raced to set down the images that filled

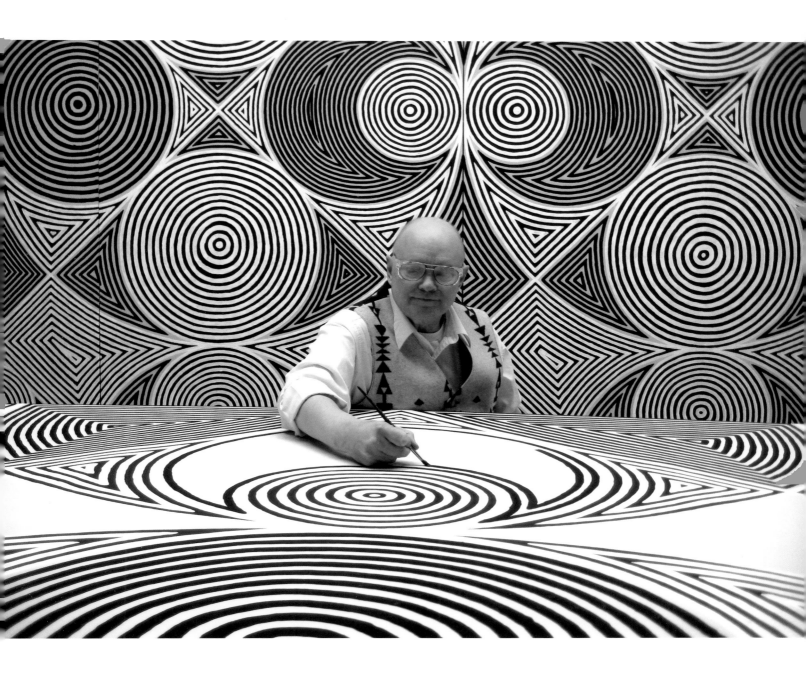

Figure 68
Dick painting in his
studio, 2007. Photo: Jane
Orleman.

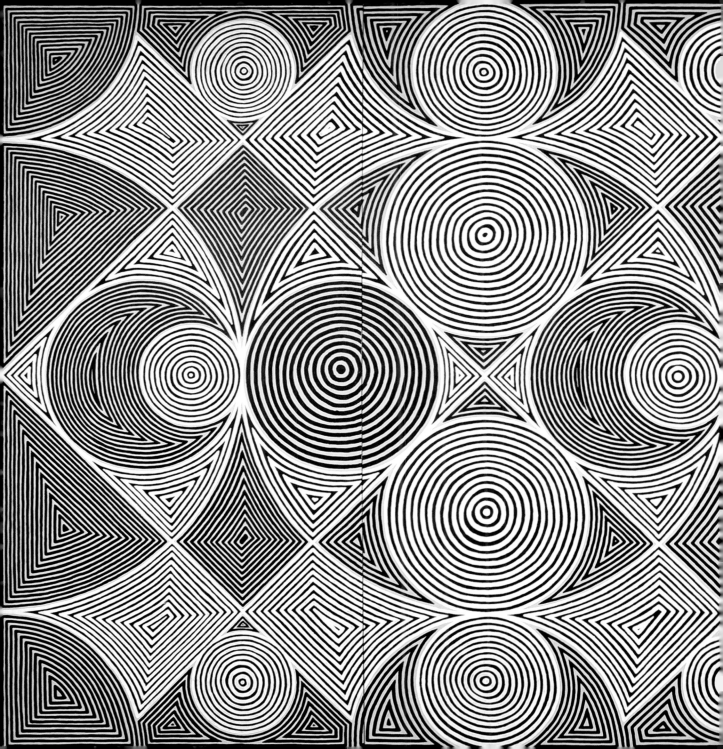

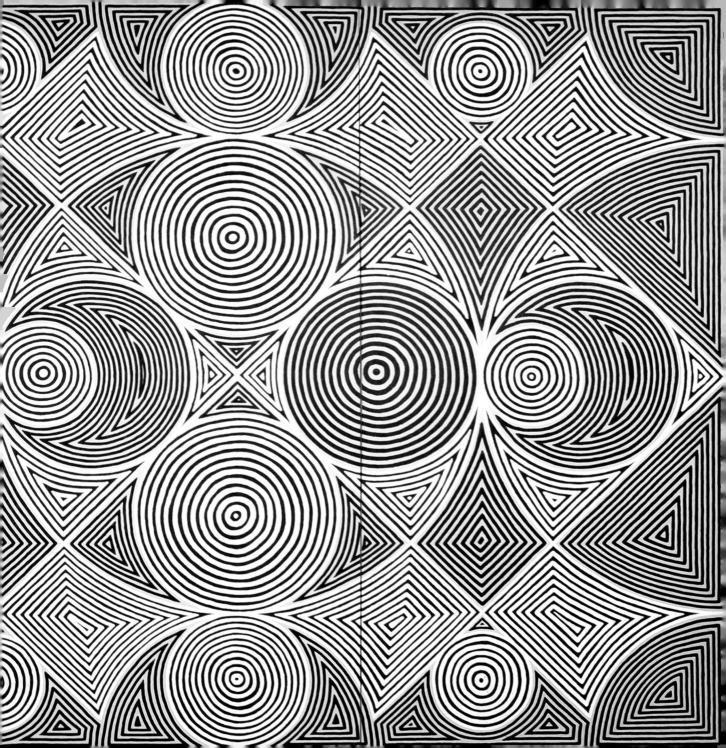

84

his mind. The possibilities seemed limitless after the restricted,
five-color palette of the reflectors. With some 4,000 color gra-
dations at hand, Elliott's imagery took on a joyous, almost out-
of-body lightness (figs. 72–73, 75). With patterns common to
Buddhist mandalas, Islamic architectural ornamentation, and
Gothic rose windows, Elliott focused on the kind of imagery that
sends a shiver to our psyches: "like tuning forks setting up a reso-
nating vibration that brings our soul into its harmonic."[2]

During this period of intense creativity, Elliott even collaborated
with artist Kent Swanson on a series of Primal Op pots and plates

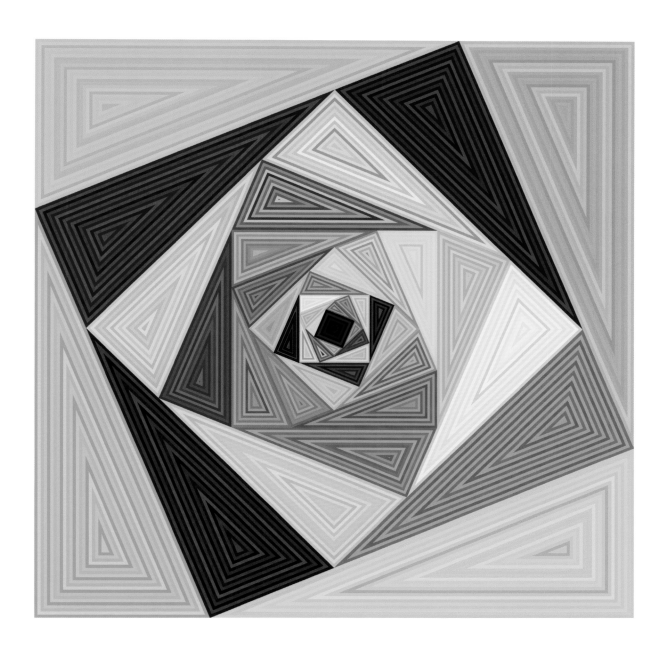

85

Figure 72
Vibrational Field #18,
2008, digital print, 30 x
24 in., *collection of the
Hallie Ford Museum of
Art, Willamette University,
Maribeth Collins Art
Acquisition Fund,
2008.030.018. Photo:
Richard C. Elliott Estate.

(fig. 74). The computer, however, allowed him to complete in a few days a painting that would take months with a brush. He worked obsessively. Time was closing in. After he completed number 57 of his *Vibrational Field* series (fig. 76), Dick told Jane: "If this is the one I have to end on, I'm okay with that."

Throughout their marriage, Jane—in addition to her own painting and writing—had been Elliott's able helpmate: editing and correcting his proposals, doing the bookkeeping, managing the archives, the website, writing press releases, being the pragmatic boots on the ground that allowed Dick's creative work to flow easily. They were, as one friend said, "a binary entity,"[3] their lives and artwork interwoven. During these months of physical decline, Dick relied on her for nearly everything.

On November 19, 2008, after a pleasant day of phone calls with family and friends, and quiet conversation with Jane, Dick said, "Jane, I don't know if I made the art or if I am the art." An hour later, he was gone.

Figure 73
Vibrational Field #33, 2008, digital print, 30 x 24 in., collection of the Hallie Ford Museum of Art, Willamette University, Maribeth Collins Art Acquisition Fund, 2009.005.009. Photo: Richard C. Elliott Estate.

Figure 74
Primal Op Pots and Plate (with Kent Swanson), 2008, carved ceramic, various dimensions, collection of Jane Orleman, Ellensburg, Washington.

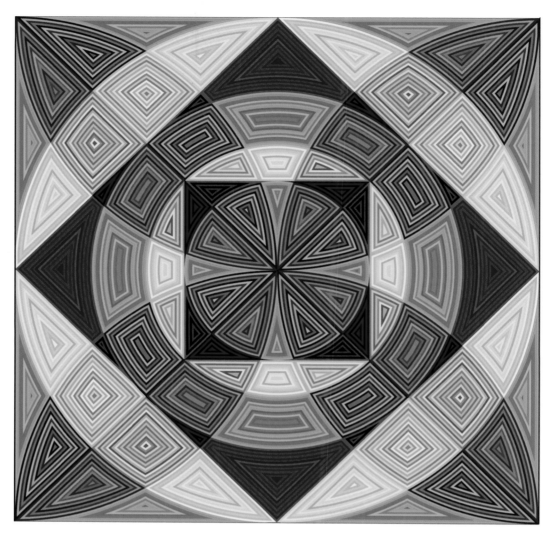

Figure 75 (above)
Vibrational Field #3,
2008, digital print, 30 x
24 in., collection of the
Hallie Ford Museum of
Art, Willamette University,
Maribeth Collins Art
Acquisition Fund,
2008.030.003. Photo:
Richard C. Elliott Estate.

Figure 76 (opposite)
Vibrational Field #57,
2008, digital print, 30 x
24 in., collection of the
Hallie Ford Museum of
Art, Willamette University,
Maribeth Collins Art
Acquisition Fund,
2009.005.017. Photo:
Richard C. Elliott Estate.

The body of work Elliott left behind is, in one sense, unprec-
edented. In his layered reflector pieces—the individual works on
canvas, large-scale museum installations, and site-specific public
artworks across the country—Elliott pioneered a new art medium.
While his approach remained a product of Elliott's post-World
War II generation as he worked through Photorealism, optical art,
performances, and installations, he also tapped into something
eternal. With his breakthrough style, Elliott discovered a new way
to express the spiritual potential of art, its deep roots in our collec-
tive psyche. His work deserves a place in American art history.

NOTES

1 The name was coined in a *Time* magazine story by John Borgzinner called
 "Op Art: Pictures that Attack the Eye" 84(17) (October 23, 1964): 78–86.
2 Elliott, "An Infinite Point in Time: The Visually Sensuous and Emotionally
 Joyous Art of Richard C. Elliott," 1999, http://www.reflectorart.com/dick/
 infinite-point/index.html (accessed January 7, 2014).
3 John Hofer, interview with the author, November 5, 2013.

RICHARD C. ELLIOTT
(1945–2008)

Background

1993	Neon Art and Tube Bending School, Portland, Oregon
1992	Awarded patent #5,079,644 for method of layering reflectors
1978	Co-created Dick and Jane's Spot, an art site in Ellensburg, Washington
1971	Married artist Jane Orleman
1963–71	BA in Art, Central Washington University, Ellensburg, Washington
1968–69	VISTA Volunteer, with Makah Indians in Neah Bay, Washington
1966–67	VISTA Volunteer, with Eskimos at Pilot Station, Alaska

Grants, Fellowships, and Awards

2008	Americans for the Arts Recognition for Innovation in Public Art, Philadelphia, Pennsylvania
	The Larson Gallery Arts Award for Outstanding Contributions to the Arts, Yakima, Washington
	The Governor's Award for the Arts, Olympia, Washington
2007	The Theo Van Gogh Award, Gallery One Visual Arts Center, Ellensburg, Washington
2002	Artist Trust/Washington State Arts Commission Fellowship, Seattle, Washington
2000	Distinguished Alumni, School of Arts and Humanities, Central Washington University, Ellensburg, Washington
1998	Visiting Artist Grant, University of Calgary, Alberta, Canada
1995	Artist Fellowship, Inc., New York, New York
1994	National Endowment for the Arts Grant, Washington, DC
1993	Western States Arts Federation, Santa Fe, New Mexico
1992	Greater Wenatchee Community Foundation, Wenatchee, Washington
	Art Matters, Inc., New York, New York
1991	Emergency Grant, Adolph and Esther Gottlieb Foundation, New York, New York
1989	GAP Grant, Artist Trust, Seattle, Washington
	Fellowship, Bellevue Art Museum, Bellevue, Washington

Selected Commissions

2009 *Chain of Life*, TriMet Light Rail, Clackamas Town Center Station, Portland, Oregon

2008 *Portals Through Time*, Hallie Ford Museum of Art, Willamette University, Salem, Oregon

 St. Louie Rhythm, St. Louis Arts in Transit, St. Louis, Missouri

 Sound of Light, Seattle Sound Transit, Light Rail Corridor, Seattle, Washington

2007 *Tower of Light*, CATS Archdale Station, Charlotte, North Carolina

 Crossroads, Tacoma School District, Jefferson Elementary School, Tacoma, Washington

 Thunder Over the Rockies, Regional Transportation District, Belleview Light Rail Station, Pedestrian Tunnel, Denver, Colorado

2005 *River*, City of Renton, Municipal Parking Garage, Renton, Washington

 Eyes on the World, Port of Seattle, Sea-Tac International Airport, SeaTac, Washington

 Fractals and Trees, Oregon State University, Kelly Engineering Building, Corvallis, Oregon

2004 *It's the Wave Not the Water*, Oregon State University, Hinsdale Wave Research Laboratory, Corvallis, Oregon

 Then Till Now, Hiawatha Light Rail, Minneapolis, Minnesota

 Five Neons, City of Seattle, Wallingford Library, Seattle, Washington

2003 *Millennium Labyrinth*, Kittitas County Millennium Project, Ellensburg Library Rotary Plaza, Ellensburg, Washington

2002 *Reflective Light Rhythms*, Spokane Valley School District, University High School, Spokane Valley, Washington

1996 *Rainbow Bridge*, Lake Washington School District, Eastlake High School, Redmond, Washington

1995–96 *Wings of Light*, Boise Art Museum, Boise, Idaho

1993–94 *Noise Reduction Apparatus #1*, Times Square, New York, New York

1992 *Circle of Light*, Sun Dome, Yakima, Washington

 Reflections on the Columbia, Pateros Chamber of Commerce, Pateros, Washington

1989–90 *Cycle of the Sun*, Henry Art Gallery, University of Washington, Seattle, Washington

Selected Installations

2008 *Central Core*, Market Place, sponsored by the Museum of Art, Washington State University, Pullman, Washington

2000 *9,878,400 DOTS* (an unofficial exhibition), Sarah Spurgeon Gallery, Central Washington University, Ellensburg, Washington

1996 *Explorations in Light*, Whatcom Museum of History and Art, Bellingham, Washington

1995 *Wings of Light*, Boise Art Museum, Boise, Idaho

1994 *Seeing the Light*, Paris Gibson Square Museum of Art, Great Falls, Montana

1993 *Soul Rhythms*, Northlight Gallery, Everett Community College, Everett, Washington

 OH WOW, Pritchard Art Gallery, University of Idaho, Moscow, Idaho

Reflections of the Cosmic Soul: Part One, The Primal Symbols, Cheney Cowles Museum, Spokane, Washington

Reflections of the Cosmic Soul: Part Two, The Map of Heaven, Gallery of Art, Eastern Washington University, Cheney, Washington

1992 *Flash-Light*, Security Pacific Gallery, Seattle, Washington

 Jewels of Avalon, The Art Gym, Marylhurst University, Lake Oswego, Oregon

1991 *In the Dark*, Larson Gallery, Yakima Valley Community College, Yakima, Washington

1990 *Primal Reflections*, Sarah Spurgeon Gallery, Central Washington University, Ellensburg, Washington

 Portable Lunar Observation Piece, Business Volunteers for the Arts, 10th Anniversary Celebration, Seattle, Washington

1989–90 *Cycle of the Sun*, Henry Art Gallery, University of Washington, Seattle, Washington

1989 *Reflector Madness*, Foundation Gallery, Skagit Valley Community College, Mount Vernon, Washington

1984 *Portable Lunar Observation Piece*, Art in the Park Celebration, Yakima, Washington

1982 *Magic Circle*, Traver/Sutton Gallery, Seattle, Washington

Selected Solo Exhibitions

2014 *Richard C. Elliott: Primal Op*, Hallie Ford Museum of Art, Willamette University, Salem, Oregon

2010 *Richard C. Elliott: Vibrational Field Paintings*, Sarah Spurgeon Gallery, Central Washington University, Ellensburg, Washington

2009 *Into the Infinite: The Art of Richard C. Elliott*, Yakima Valley Museum, Yakima, Washington

93

2008 *Forms/Lines, Swanson & Elliott*, Clymer Museum of Art, Ellensburg, Washington

 Labyrinth Series, Gallery One Visual Art Center, Ellensburg, Washington

 Vibrational Field Paintings, Clymer Museum of Art, Ellensburg, Washington

2007 *Primal Op*, Gallery One Visual Art Center, Ellensburg, Washington

2006 *Eidetic Variations/Central Core/Defining Full View*, Larson Gallery, Yakima Valley Community College, Yakima, Washington

2004 *Richard C. Elliott: Reflections and Meditations*, Washington State University, Pullman, Washington

2000 *Luminous: A Winter Festival of Lights*, Allied Arts of Yakima, Yakima, Washington

1997 Brian Ohno Gallery, Seattle, Washington

1996 *Explorations in Light*, Whatcom Museum of History and Art, Bellingham, Washington

1995 *Inner Fires: Neon Sculptures and Reflector Works*, Boise Art Museum, Boise, Idaho

1990 *Reflective Light Paintings*, Mia Gallery, Seattle, Washington

1989 Deson-Saunders Gallery, Chicago, Illinois

1988 *Light in Spirit*, Mia Gallery, Seattle, Washington

1986	Jamison-Thomas Gallery, Portland, Oregon
1978	Marylhurst University, Lake Oswego, Oregon

Selected Invitational and Group Exhibitions

2007	*CWU Alumni Exhibition: Crossroads and Connections*, Sarah Spurgeon Gallery, Central Washington University, Ellensburg, Washington
2005	*Sound Transit: MLK Corridor Artists*, Columbia City Gallery, Seattle, Washington
2003	*Yard Art*, Hallie Ford Museum of Art, Willamette University, Salem, Oregon
	35 Artists/35 Years, Gallery One Visual Art Center, Ellensburg, Washington
1998	*Contemplating Eternity*, Rental/Sales Gallery, Seattle Art Museum, Seattle, Washington
1997	*Two Artists One Bed*, Cheney Cowles Museum, Spokane, Washington
	Northwest Neon, Cheney Cowles Museum, Spokane, Washington
1996	*Yard Art*, Whatcom Museum of History and Art, Bellingham, Washington
1995	*Interior Idioms: The Idiosyncratic Art of Eastern Washington*, Seafirst Bank, Seattle, Washington
	The Wrecking Ball, Henry Art Gallery, University of Washington, Seattle, Washington
	Birds in Paradise, Mary Porter Sesnon Gallery, University of California, Santa Cruz, California
1992	*Re-Play*, College of DuPage, Glen Ellyn, Illinois
1991	*Northern Lights*, Port Angeles Fine Arts Center, Port Angeles, Washington
	Yard Art, Boise Art Museum, Boise, Idaho
1989	*On the Edge: New Prints*, Mia Gallery, Seattle, Washington
1988	*Yard Art*, Mia Gallery, Seattle, Washington
1985	Jamison/Thomas Gallery, Portland, Oregon
1983	*The Rock Show*, Open Mondays Gallery, Seattle, Washington
1982	The Rock Festival, Bothell, Washington

Selected Juried Exhibitions

2008	*Annual Juried Exhibition*, Gallery One Visual Art Center, Ellensburg, Washington (also 2005, 2004, 2003, 2000, 1999, and 1998)
2005	*Annual Central Washington Artists Exhibition*, Larson Gallery, Yakima Valley Community College, Yakima, Washington (also 2003, 2002, 2001, 2000, 1999, 1998, 1997, 1992, 1991, 1990, 1989, 1988, 1987, 1986, 1984, 1980, 1979, and 1975)
2005	*Annual Juried Art Exhibition*, Allied Arts of Yakima, Yakima (also 2001)
	Patterns, Rhythms, and Cycles, Mt. Scott Art Center, Portland, Oregon
1999	*Northwest Annual*, Center for Contemporary Art, Seattle, Washington (also 1989)
1991	*Art Splash '91*, Redmond, Washington

1989 *Pacific Northwest Arts and Crafts Fair Exhibition*, Bellevue Art Museum, Bellevue, Washington (also 1984, 1983, 1975)

1988 *Northwest Juried Art Exhibition*, Cheney Cowles Museum, Spokane, Washington (also 1970)

1987 *Painting/Sculpture '87*, Tacoma Art Museum, Tacoma, Washington

1985 *Clemson National Print and Drawing Exhibition*, Lee Gallery, Clemson University, Clemson, South Carolina

 Oregon/Washington Juried Art Exhibition, Maryhill Museum of Art, Goldendale, Washington

1978 *Oregon Biennial*, Portland Art Museum, Portland, Oregon (also 1976)

1976 *National Drawing Competition*, Bellevue Art Museum, Bellevue, Washington

1976 *Paperworks II*, Portland Art Museum, Portland, Oregon

Selected Lectures and Workshops

2008 Jefferson Elementary School, Tacoma School District, Tacoma, Washington

2006 Dick and Jane's Spot, Ellensburg, Washington, sponsored by the Washington State Arts Commission

2003 Hallie Ford Museum of Art, Willamette University, Salem, Oregon

1999 Eastern Oregon University, La Grande, Oregon

1998 University of Calgary, Calgary, Alberta, Canada

1996 Whatcom Museum of History and Art, Bellingham, Washington

 Eastlake High School, Lake Washington School District, Redmond, Washington

1995 Boise Art Museum, Boise, Idaho (also 1991)

 Central Washington University, Ellensburg, Washington (also 1990)

1994 Paris Gibson Square Museum of Art, Great Falls, Montana

1993 University of Idaho, Moscow, Idaho

 Cheney Cowles Museum, Spokane, Washington

 Eastern Washington University, Cheney, Washington

1992 College of DuPage, Glen Ellyn, Illinois

 Marylhurst University, Lake Oswego, Oregon

1991 Yakima Valley Community College, Yakima, Washington

1990 Tacoma Art Museum, Tacoma, Washington

1989 Skagit Valley College, Mount Vernon, Washington

 Henry Art Gallery, University of Washington, Seattle, Washington

1988 Bellevue Art Museum, Bellevue, Washington

1987 Pacific Lutheran University, Tacoma, Washington

For further information on Richard C. Elliott, including his full biography and examples of his studio work, commissions, installations, videos, and writing, please visit the artist's website at www.reflectorart.com

ABOUT THE AUTHOR

Sheila Farr lives in Seattle and participates in the Northwest arts scene as an author, poet, and critic. Her books include *Leo Kenney: A Retrospective* (2000), *Fay Jones* (2000), and *James Martin: Art Rustler at the Rivoli* (2001), and she is co-author of *Leo Adams: Art, Home* (2013) and *Robert Davidson: Abstract Impulse* (2013). As staff art critic for *The Seattle Times* from 2000–2009, and before that, for the *Seattle Weekly*, she received a number of honors for journalistic excellence, including a George Polk Award.